ABANDONED
DERBYSHIRE

NATHAN FEARN

AMBERLEY

First published 2024

Amberley Publishing, The Hill, Stroud
Gloucestershire GL5 4EP

www.amberley-books.com

British Library Cataloguing in Publication Data.
A catalogue record for this book is available from the British Library.

ISBN 978 1 3981 1219 3 (print)
ISBN 978 1 3981 1220 9 (ebook)

Typesetting by SJmagic DESIGN SERVICES, India.
Printed in Great Britain.

Contents

Introduction

There is something about abandoned sites that is incredibly evocative. Whether it's a once-grand stately home clinging onto the last remnants of its former beauty, a crumbling castle reduced to its foundations or an old mill standing forgotten, reclaimed by the land it once exploited, these buildings and places stir something inside us. What would this place have looked like in its heyday? Why did it decline? Who lived here? What would past occupants think if they could see it now? What conversations and events took place within its four walls and what were the consequences of them? All these questions and more spring to mind when we come across somewhere irrevocably altered by time and circumstances.

What is often so compelling about many of Derbyshire's abandoned buildings and locations is the tantalising balance between what we know and what we don't. We owe much to contemporary writers, historians, enthusiasts and heritage organisations who have documented so much about the places we have lost, or are in the process of losing. Yet, for all that is documented there remains much about Derbyshire's abandoned locations that capture our imaginations and captivate us. Take the first places featured in this book: the lost villages of Derwent and Ashopton. We know when the last church services were held there, even the hymns that were sung. What we don't know is how the congregations must have felt during those services, knowing their churches – and their homes – would soon be condemned to the depths of a reservoir and lost forever.

This book draws inspiration from all areas of the county and explores a wide and diverse range of buildings and places that, in their own unique ways, have left their imprints on the fabric of Derbyshire life. Yet, ultimately, most of them could not win their respective battles against the formidable foes of time and progress.

Every effort has been made to ensure accuracy in chronicling these places, with dates, events and information fact-checked where possible and specific sources cited where necessary. No personal risks or trespassing took place during the writing of this book, and it should be noted that some of the places featured here are privately owned and not accessible to the public. Further guidance on site ownership and visiting information for those that can safely and legally be accessed can be found at the back of this book.

I do hope you enjoy *Abandoned Derbyshire*, which has been a pleasure to write, and that you find the stories of these fascinating places and the people associated with them as interesting as I have.

I

The High Peak

The Lost Villages of the Derwent Valley

'I may be the last person who remembers Ashopton and Derwent,' recalled ninety-two-year-old Mabel Bamford to Derbyshire-based writer Helen Moat in 2018. 'We lived in Ashopton until 1938. I was going to school in Derwent even as the construction of Ladybower was underway.'

While some abandoned places discover a new lease of life after becoming deserted, the mass exodus from the triumvirate of villages known as Derwent, Ashopton and Birchinlee was always destined to be final, the settlements never to be populated again.

The fates of all three are inextricably linked to water. The mid- to late nineteenth century saw greater numbers of workers migrate from villages with their families to towns and cities in search of employment, and one consequence of this influx to urban areas was an increased burden on water supplies. The forming of the Derwent Valley Water Board in 1899 and the subsequent construction of the Howden and Upper Derwent reservoirs in Derbyshire, which opened in 1912 and 1916 respectively,[1] helped to a point but proved only a partial solution to the problem caused by the ever-increasing demand from Sheffield, Leicester, Nottingham and wider areas of Derbyshire. It's against this backdrop that the residents of Ashopton and Derwent went about their normal lives, unaware at the time that a decision was imminent that would have a profound effect on their lives – and doom their homes forever.

By 1935, work had begun on the construction of Ladybower Reservoir and, consequently, both Ashopton and Derwent would need to be sacrificed.[2] In an age where social mobility was rarer than it is today, and relocation even more so, many who had called these close-knit communities a home for generations were now faced with the prospect of having their lives uprooted.

In both Derwent and neighbouring Ashopton the respective churches had been a focal point of village life, as was the case in villages throughout the country. Contemporary records suggest the final service at Ashopton's Methodist church took place on 25 September 1939. The final hymn is believed to have been 'The Day's Dying in the West', an evocative song that can only have added to what must have been a strange and sobering atmosphere inside a church that was on

borrowed time – especially as war had been declared just weeks before. It seems plausible then that the last words to be sung in unison ahead of the village's enforced abandonment would have been the final verse of that hymn:

> While the deepening shadows fall
> Heart of love, enfolding all
> Through the glory and the grace
> Of the stars that veil thy face
> Our hearts ascend.

The chapel, along with the remaining buildings in Ashopton, would be demolished four years later, with the village reduced to a ghost town before disappearing altogether, never to be seen again.

In the same year of Ashopton's demise, Derwent's church held its last service (on 17 March 1943), also ahead of it being abandoned. Its church bell, however, actually survives to this day, re-hung some 42 miles south in St Philip's Church, Chaddesden, Derby.

Derwent's church spire was initially granted a stay of execution, avoiding demolition so as to provide a memorial to the village. It must have been some sight for the locals, watching the spared church spire slowly disappear from view as the water rose around it. It didn't take long, however, for the spire to suffer the same fate as the rest of the village, the remains of which were now submerged in

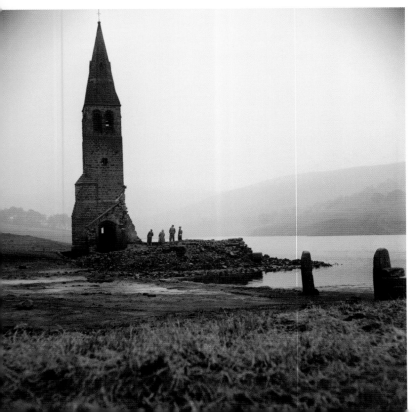

Derwent Church spire, *c.* 1946. It was demolished due to health and safety concerns in December 1947. (Richard Bradley)

water. The authorities, wisely anticipating the problems that could arise from the spire remaining in situ – not least the lure of people attempting to swim out to it – took the decision to have it removed, and it too met its end in December 1947.

Due to the sheer amount of silt that has amassed over time, it's impossible for Ashopton to ever re-emerge from the depths of Ladybower, even in its ruined state. However, it is easy to identify exactly where it once stood, with the main part of the village once occupying the area directly below where the aptly named Ashopton Viaduct now stands.

The location of Derwent, the larger of the two villages, is less easy to pinpoint by sight alone. However, the village has been known to reveal itself from the depths, emerging from the blanket of water that normally covers it. On rare occasions, periods of extreme hot weather have resulted in droughts extensive enough to allow the remains of some of Derwent's forgotten buildings to re-emerge once more. In 1976, 1995, 2003, 2018 and, most recently, 2022, cottage doorways, hearths and lower walls have revealed themselves, offering a glimpse of an area once teeming with life. Given the effects of climate change, it's quite possible Derwent will emerge at more frequent intervals in the future, although its fragile foundations will undoubtedly continue to disintegrate further as the years pass by.

Perhaps most prominent among the ruins are the remains of the once two-storeyed Derwent Hall, with its stone fireplace still largely intact – a visual reminder that this was once a place where real people led real lives before the village was condemned to the bottom of a reservoir.

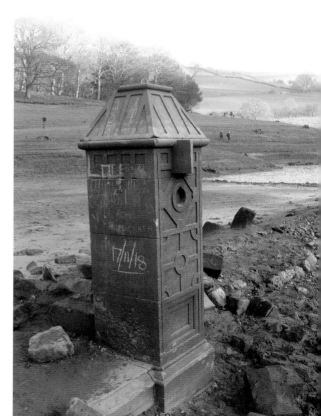

The remains of the lost village of Derwent reveal themselves from the depths during a drought in 2018. (Richard Bradley)

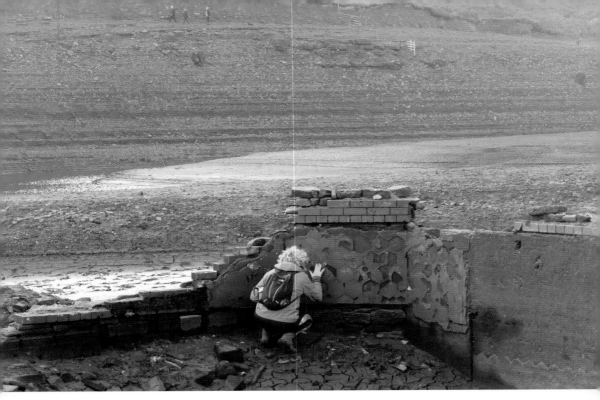

An explorer takes in the foundations of what was once Derwent Hall. (Richard Bradley)

The fates of Derwent and Ashopton is not, however, the end of the story. Surprisingly, they were not the only villages to be abandoned as a result of the reservoirs' construction. In fact, a separate village had been created, abandoned and dismantled before Derwent and Ashopton had been condemned to the depths.

Birchinlee, colloquially known as 'Tin Town' as its buildings were made from easy-to-construct and easy-to-dismantle corrugated iron, had been built from scratch to accommodate the workers (and their families) tasked with building the reservoirs. Standing between 1902 and 1916, this makeshift village took on all the characteristics of any normal Derbyshire settlement. Birchinlee boasted a school, canteen (which doubled up as a pub), post office, shops, a recreational hall, public bathhouse, police station, and even hospitals and a railway.

Despite the village's temporary nature, there's evidence of its inhabitants harnessing a real community spirit in the relatively short time they were there, with Birchinlee entering teams into numerous sports leagues, including football and cricket.

At one point, the village's population rose to around 900 inhabitants; however, despite its appearance as a fully functioning Derbyshire village, its days were always going to be limited. In fact, by the time the Upper Derwent Dam was completed in 1916, the village of Birchinlee had already been confined to history and its inhabitants gone, as if the village had never existed.

The project had been a long and ultimately successful one. However, there must have been a tinge of sadness as Birchinlee's community went their separate ways.

Above: Ladybower Reservoir with Ashopton Viaduct in the distance, where communities once lived and thrived. The remains of these villages now lie deep beneath the water. (Richard Bradley)

Below: The building of Birchinlee, aka 'Tin Town', in the early 1900s. The village no longer exists. (Paul Browne)

Unlike the villagers of Derwent and Ashopton, who were largely rehomed in nearby settlements, the relocation of Birchinlee's population is likely to have been more disparate, given people had moved into the area specifically for employment purposes.

Had he lived, one can only imagine how George Sutton – both instrumental in the development of the village and a prominent community figure as its missioner – would have felt seeing Birchinlee dismantled and its residents gone.[3] Fittingly, however, his family were the last to leave the village, surviving in the post office until 1915 as it was deconstructed around them.

Today, only the odd stone foundation survives from the temporary village, although information boards are dotted around where Birchinlee once stood, reminders of a place that many walking through will be unaware even existed.

In nearby Hope, though, remnants of the village remain. One of the huts, for example, was reassembled and is now a small hairdressers, while Birchinlee's packhorse bridge, painstakingly moved brick by brick, survives at nearby Slippery Stones where it spans the river at the head of Howden Reservoir.

These days anybody taking a stroll in the beautiful Upper Derwent Valley would do well to know the villages of Ashopton, Derwent and Bichinlee ever existed. Yet, deep beneath the waters, distinctive Derbyshire communities once thrived.

Despite the remarkable tale of the flooding of these villages for the greater good, it is another event here that has provided the area with its most enduring legacy. It was here in 1943 between Ladybower Reservoir and the Howden Dam that, for six weeks, RAF Squadron 617, better known as the Dam Busters, trained for Operation Chastise during the Second World War. Commemorative flyovers continue to this day.

Errwood Hall

Errwood Hall was built in the 1840s, and its size and elaborate Italianate and Norman features must have been mightily impressive in its prime – a majestic focal point amid acres of sprawling countryside. The centrepiece of a 2,000-acre estate in the heart of the beautiful Goyt Valley, Errwood Hall was built for the wealthy Manchester-based industrialist Samuel Grimshawe. Yet it would survive as a great dynastic mansion for fewer than 100 years before being left to terminally decline and be reduced to its foundations.

After Grimshawe's death in 1883, Errwood Hall passed to his son, and later a relative. However, the Grimshawe bloodline came to an end following the death of his granddaughter, Mary Ambrose Louisa Gosselin-Grimshawe, on 23 February 1930 and with it the Grimshawes' influence over the property came to an end.

Having passed to the Stockport Water Corporation, along with the vast estate surrounding it, Errwood Hall was let briefly to the Youth Hostel Association. However, this would be only a short reprieve. The principal reason for the purchase was the construction of Errwood Reservoir, which had been underway

Errwood Hall was once a grand residence, now only parts of its foundations remain. (Gary Wallis)

since 1931. Errwood Hall stood a considerable distance from the reservoir, but the fine stone from the building was tailor-made for the water treatment works below the reservoir and, bit by bit, this once grand structure – abandoned and its assets stripped – began to be dismantled.

These days, little of the hall remains and what does has gradually faded into the surroundings it once dominated. Only the foundations at ground-floor level and a few sections of wall now survive. Yet the relatively short life of Errwood Hall continues to spark interest.

Among the remains are spectacular fauna and flora, including rhododendrons and azaleas originally planted by the Grimshawe family, which provide a tangible link back to an era that was, for them, all too short. In recognising the beautiful surroundings, the Peak District National Park Authority, along with the Forestry Commission, created paths and trails perfect for walkers. The result is that the site of Errwood Hall enjoys a relatively high footfall, ensuring it has not faded into complete obscurity.

Further exploration reveals more secrets of Errwood Hall's past. To the north of its ruins, a small stone shrine still stands, defiant despite the destruction that took place around it long ago. Erected by the Grimshawes, who were staunch Catholics, it was created in memory of Miss Dolores de Ybarguen, a Spanish aristocrat who was teacher at the estate's school and governess to the family. Head to this quirky structure and, through close inspection, you'll find the inscription 'D de Y' along with the date '1889' carved into the stone.

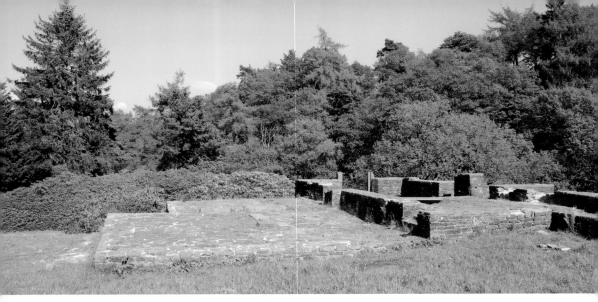

Once the centrepiece of a 2,000-acre estate, it didn't take long for Errwood Hall's decline to begin. (Gary Wallis)

The landscape at Errwood Hall may have changed immeasurably and irreversibly since the days in which Samuel Grimshawe realised his grand vision, yet he and his family's influence on the site remains.

A625 Abandoned Road

Many of Derbyshire's abandoned places have risen and fallen as a result of societal change. People come and go, circumstances alter and time passes by. The result can be a once-prominent and/or great structure slowly – or quickly – becoming redundant and falling into disrepair. This isn't always the case, though. Sometimes, Mother Nature plays a defining role. Lying below the magnificent spectacle of Mam Tor are the remains of a half-mile section of road that acts as a reminder, if one was needed, of nature's power and the unpredictable – albeit beautiful – nature of the Peak District's topography.

Mam Tor itself, which stands at 1,696 feet, dominates the skyline around this now former stretch of road and is often referred to as 'Shivering Mountain', given the area's propensity for frequent landslides.

This A625 road, spanning two counties (South Yorkshire and Derbyshire) in its entirety, was built in 1819 and is referred to by some locals as the 'new road', linking the village of Castleton with the High Peak town of Chapel-en-le-Frith. It crossed the main body of the landslide that created Mam Tor some 4,000 years ago.

Landslides, which are particularly frequent following spells of heavy rain, plagued the new road in the years following its opening, including significant disruption leading to temporary closures and necessary repairs in 1912, 1933, 1946, 1952 and 1966. It was the late 1970s, however, that would ultimately seal

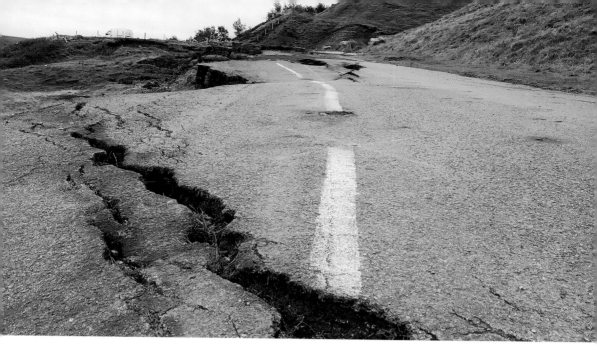

Above: Once used regularly by cars, the abandoned stretch of road is now impassable. (Mike Onslow)

Right: Built in 1819, the so-called New Road connecting Castleton with Chapel-en-le-Frith was beset with problems, leading to its eventual abandonment. (Mike Onslow)

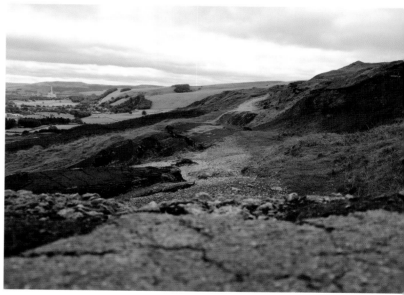

its fate. In 1977, yet another landslide meant the road was limited to single-lane traffic. Just two years later, a slow-moving landslide saw the road shut completely.

As a result of the all-to-regular chaos and disruption, as well as mounting repair costs, it never reopened, the route instead diverted westwards through Winnats Pass, an ancient packhorse road. This ill-fated stretch of road has since gradually blended back into the rugged landscape from which it came. White lines that once indicated the middle of the road now sprawl haphazardly in all manner of directions.

Above: Still enjoyed today by visitors on foot, the road never reopened to cars after yet another landslide caused its closure in 1979. (Pygarian Nox)

Left: The road is slowly being reclaimed by the dramatic landscape that surrounds it. (Ethan Lloyd)

However, it hasn't been entirely abandoned to the mercy of the elements. In its dilapidated state the road has become popular with walkers, cyclists, photographers and mountain-biking thrill-seekers, all compelled to explore the rather bizarre sight of a naturally dismantled road set against a glorious and picturesque backdrop that was, ultimately, the cause of its downfall.

Over Exposed, Bleaklow

Some of the county's abandoned landmarks are places of sombre and poignant reflection. One such site exists on Bleaklow, one of the Peak District's highest and most remote points, close to the town of Glossop and Kinder Scout, Derbyshire's highest natural summit. It was here on the windswept, isolated Dark Peak moors that US Air Force Boeing RB-29A Superfortress came down in difficult conditions in 1948, claiming the lives of all those aboard – eleven crew and two military passengers.

Modified for photographic assignments, the bomber bore the name *Over Exposed*, having been flown in July 1946 to take images of American nuclear testing at Bikini Atoll. The same aircraft had also helped facilitate the famous Berlin airlift in the same year. For all its international assignments to far-flung places, it would meet its tragic end high up in the Peak District.

The Superfortress had been conducting a routine flight on that fateful day of 3 November 1948, departing RAF Scrampton, near Lincoln, at 10:15 a.m. en route to the US Air Force base at Burtonwood, 125 miles away. Relying on instruments far more rudimentary than those found in modern aircraft and hampered by low

Much of the B-29 Superfortress wreckage remains on the moors to this day, along with a memorial erected by the Royal Air Force in 1988. (Ian Richardson)

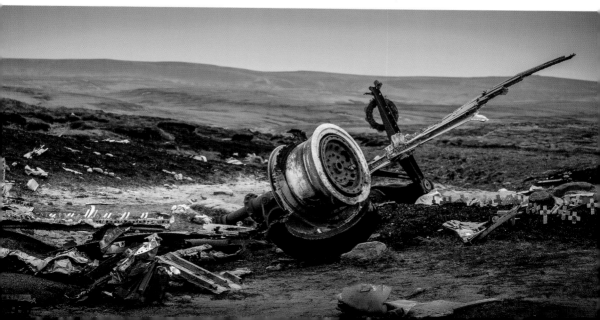

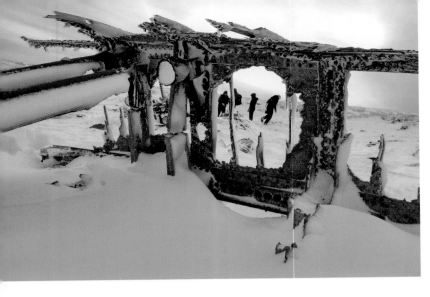

The moors around Bleaklow are notorious for their harsh weather conditions, which ultimately lead to the plane's demise in 1948. (Kirsten Marsh)

cloud, the plane made the fatal miscalculation – based on flight time – that they were past the hills of Bleaklow and began to descend.

Around forty-five minutes after take-off the aircraft hit Higher Shelf Stones, where it burst into flames and crashed, costing the lives of all those on board. The remains of the plane were located at around 4.30 p.m. the same day as the light began to fade. Only the tail section remained intact.

Over seventy-five years since the tragic event on Bleaklow, debris still lies abandoned. Indeed, a significant amount of the wreckage remains visible, including wing and fuselage sections, the undercarriage and gun turrets as well as the Duplex-Cyclone engines, which sit dramatically where they fell.

The crash scene was still giving up secrets as late as the 1970s, when a local man found a ring at the site. It was later identified as the wedding ring of Captain Tanner, one of the eleven to be lost, and subsequently returned to his daughter.

The wreckage has never been moved or cleared since *Over Exposed* met its end in 1948. At the crash site, an American flag flies as a tribute to those who perished, alongside a memorial, erected in 1988, to honour the crew's memory. It reads:

Here lies the wreckage of B-29 Superfortress 'Over Exposed' of the 16th. Photographic reconnaissance squadron USAF. Which tragically crashed whilst descending through cloud on 3rd November 1948 killing all 13 crewmembers. The aircraft was on a routine flight from RAF Scampton to American AFB Burtonwood. It is doubtful the crew ever saw the ground. Memorial laid by 367 Air Navigation Course of RAF Finningley on November 12th 1988.

Over Exposed, sometimes referred to as the 'Bleaklow Bomber', was not the first, nor last, aircraft to succumb to harsh and difficult conditions over Bleaklow in the dangerous days before modern navigation technology. It was, however, the incident that has left the most enduring and visible mark.

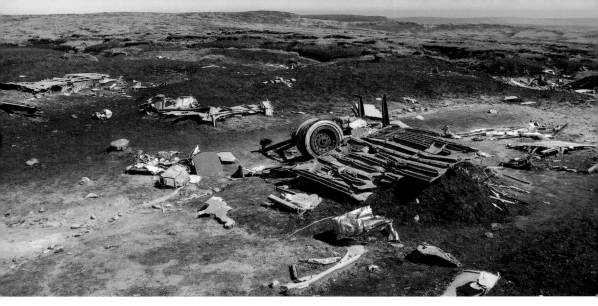

Above: The crash site. (Pygarian Nox)

Below: An American flag flies as a mark of respect for those who lost their lives. (Stephanie Reaney)

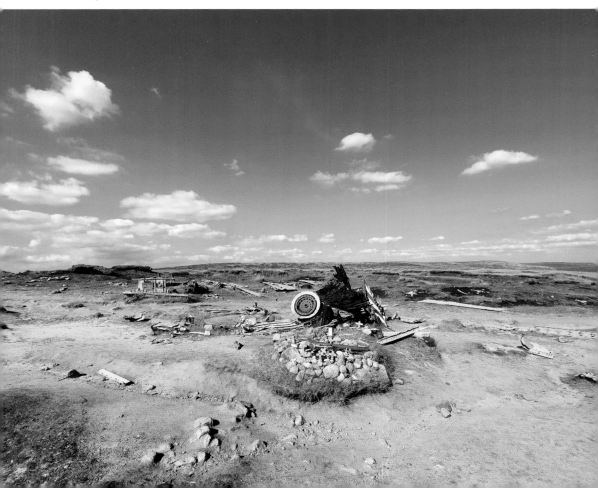

2

North East Derbyshire

Trinity Chapel, Brackenfield

Despite being a Grade II listed building since 1967, Trinity Chapel, a mile from the village of Brackenfield and Ogston Reservoir, lies far from view, buried in woodland. It is the chapel that time forgot.

Make a trip into the woods it inconspicuously sits in, and you could easily miss the structure, such is the extent of the rampant undergrove now steadily consuming it. The stone building dates back to Tudor times, although evidence suggests a place of worship has existed on the site in various incarnations since at least the eleventh century. It would have once stood out against the landscape it sits in, yet it is now much altered: missing its roof and largely hidden from view, obscured by the many chestnut trees that surround it.

The interior of Trinity Chapel. (Mike Edwards)

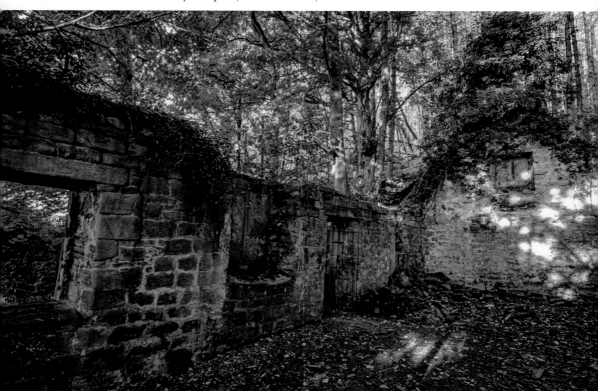

Gladwyn Turbutt – more on him shortly – speculated back in the nineteenth century that 'it is not unlikely that Hugh Willoughby, Sergeant at Arms to Henry VIII, rebuilt Trinity Chapel as a memorial to his wife Margaret, who died in 1511 ... the chapel came under the jurisdiction of the rectors of Morton. It had the rights of baptism and marriage, but not of burial, explaining the lack of gravestones surrounding it,' while also observing that the chapel is 'literally built into the side of the hill, which must have been excavated for the purpose...'[1]

The effort taken to excavate the land by Trinity Chapel points to a site that once enjoyed considerable importance and significance. Records show it was popular as a place of worship until 1856/57, and contemporary accounts testify to it once being a linchpin of the community it served in its heyday.

Commenting in June 1823, Archdeacon Butler reported that Trinity had 'accommodation for about 100 people' and it was not uncommon for the little chapel to be so full – with women housed on the north side of the chapel and men on the south – that the congregation would spill out onto the hillside.[2]

Such halcyon days in the long history of the chapel were, though, not to last. By 1841, fifteen years before it was officially abandoned, it was already in a state of decline and falling rapidly from the consciousness of the Brackenfield community. Revd Lund of Morton wrote at the time that 'Trinity Chapel is almost deserted; frequently there are no worshippers at all.'[3]

As with many abandoned structures, it was not just the sands of time that proved to be Trinity's eventual undoing and demise, but societal changes too.

The chapel has been slowly reclaimed by nature. (Mike Edwards)

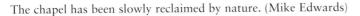

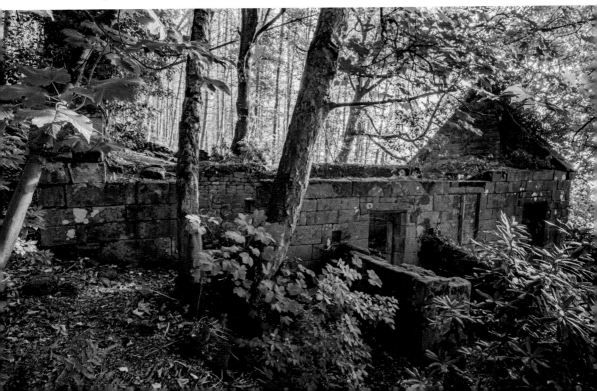

While nearby Morton held influence over the church, 1854 marked a significant change as Brackenfield was given status as a separate parish and the village wasted little time in exercising its newfound freedom by building a new church. Also to be dedicated to the Holy Trinity, this new church was built in a more convenient, central location – something that had been argued for generations before it became a reality – rendering the original chapel obsolete after centuries of use. Two years later, in 1856, it shut its doors for the final time.[4]

Did the villagers mourn the loss of their chapel, where their ancestors had worshipped before them? Or did the opportunity to enjoy a new church closer to their community supersede any sense of nostalgia and loss? What is almost certainly true is that Brackenfield's inhabitants of the 1850s and earlier would be taken aback and, you would imagine, saddened by its current state, which would be borderline unrecognisable to them.

One part of Trinity Chapel was saved before the decline set in, however, and it is an element of the former chapel past users would still recognise today. Trinity's striking wooden rood screen – a common sight in late medieval churches – was transported some twenty-five years after the church had been abandoned and was successfully moved to the new one in 1881. In the quarter of a century that

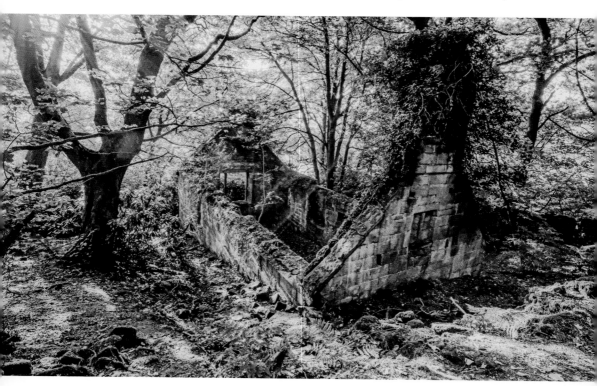

Now abandoned and isolated, Trinity Chapel was once a thriving place of worship. (Mike Edwards)

had passed, the rood screen, consisting of a central doorway and carved, open arcading, had unsurprisingly fallen into disrepair and largely had to be restored, but it can still be found in the present-day church. It is a poignant nod to the nearby chapel in the woods that it was once a part of.

Holy Trinity Church, the 'new' church, which is in fact now more than 160 years old, continues to welcome worshippers and members of the local community and has, of course, developed its own history and stories. It can be found on Ogston New Road, Brackenfield.

As with many of these types of abandoned buildings, a veil of mystique and sentimentality covers Trinity Chapel. Now largely forgotten, it continues to provide inspiration for those who go seeking it, compelled by its backstory and attracted to its setting. The chapel's ruins and the woodland that surrounds it even featured in the 2017 George Popov-directed thriller *Hex*, set during the English Civil War – a time when, ironically, Trinity Church was still flourishing.

With each passing year, Trinity Chapel continues to fade further into its surroundings and becomes less and less stable as the woodland takes a firmer hold. So far gone is the chapel that it is currently on Historic England's 'At Risk' register. For now, it survives – a relic from an era that left it behind.

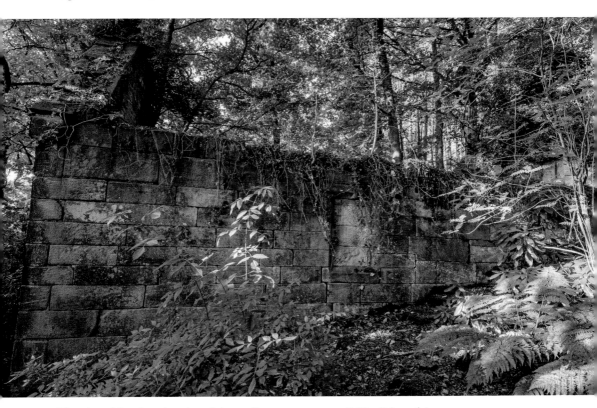

The chapel has lay abandoned for well over 150 years. (Mike Edwards)

Seldom Seen Engine House

Ask two Eckington natives whether their allegiances lie with South Yorkshire or Derbyshire and there's every chance you'll receive two different answers.

Just 7 miles north-east of Chesterfield and 8.5 miles south-east of Sheffield city centre, the town lies on the very north-eastern fringes of the county. Confusingly, perhaps, it has a Sheffield postcode despite being under the authority of North East Derbyshire District Council.

The mineral-rich town, like many in the north-east of the county, prospered during the Industrial Revolution, with coal and iron ore mined and abundant streams – such as Moss Brook – providing employment opportunities and a source of wealth for the area. It is over Moss Brook and into Eckington Woods, just under 1 mile north-west of the town, that you'll find the curiously named Seldom Seen Engine House.

Dating from between 1855 and 1875, its name feels almost ironic as you approach, standing out remarkably well for an abandoned place surrounded by woodland and imperious in comparison to many other buildings of its type dotted around the county. This is largely due to its size. At 75 feet tall it stands unusually high for an engine house and, as such, was granted Scheduled Ancient Monument status in March 1998.

A product of Eckington's former industrial prowess, it is the last remaining building of the now defunct Plumbley Colliery, and has, in the past, relied on restoration works by Derbyshire County Council to ensure it remains structurally sound.

The colliery, which according to Historic England was operating by 1875 and reached its full extent by 1897, was disused by the outbreak of the First World War and the engine house was left to ruin. While the cogs in this now peaceful woodland have long since stopped turning, peer inside the shell of Seldom Seen Engine House and it's not too hard to imagine the industry that would have once made the area a hive of activity.

For safety reasons it isn't possible to go inside the actual structure, although the interior is clearly visible from the metal-gated opening. The numerous windows, where the bearing walls built to accommodate a beam engine can still be seen. Similarly, elements of a brick chamber survive, built against the west wall that would have once housed a boiler.

The main interior walls also bear the hallmark of years of previous use, with black blotches evident in certain areas and bricked-up windows indicating modifications to the structure during its working life as ways of working and the technology available continued to evolve.

While its height is rare, its name is almost certainly unique. Why 'Seldom Seen'? Well, there appears to be two main strands of thought. One is that the site is haunted, with the ghosts that inhabit it and the area 'seldom seen'. The significantly more credible theory offered is that, nestled at the bottom of a valley, the engine house was less conspicuous than many similar structures and industrial sites of the day.

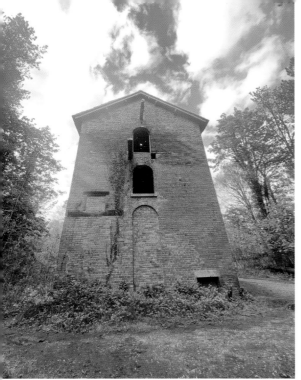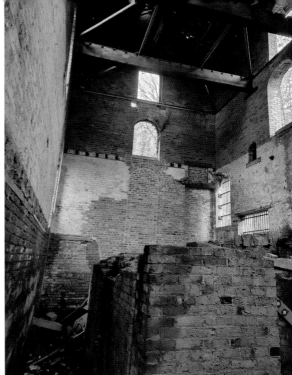

Above left: Seldom Seen Engine House. (Amelia Campbell)

Above right: The interior of the unusually tall Seldom Seen Engine House. (Becky Adlington)

While the site of Seldom Seen Engine House offers evidence of the area's industrial past, it also provides a poignant backdrop to a tragic event that occurred near the abandoned structure. On 16 March 1895, three children – Percey Riley, Esther Ann Riley and Rebecca Godson – died after the ice they had been playing on at a nearby pond broke, with all three falling into the icy water.

A young colliery worker, Alfred Williamson, heard the cries and valiantly attempted to save them but, unable to swim, perished with them. Alfred's headstone, which includes the name of the three children, stands at nearby Eckington Churchyard.

The parents of the three children were unable to afford headstones, but in a touching display of community spirit this was rectified as recently as 2020, when local residents raised enough money to provide hand-carved headstones. A special service was held at Eckington Church on 15 March of that year where the headstones were unveiled, in the process marking the 125th year since that sad day.

Sutton Scarsdale Hall

You could be forgiven for assuming an abandoned building that has been without its roof for more than 100 years would not have an awful lot going for it. However,

Sutton Scarsdale Hall is not your archetypal abandoned building. It is, in fact, one of the most curious derelict structures the county has to offer.

Stood imperiously at the summit of a hill close to Chesterfield and Bolsover, this Grade I listed Georgian stately home, designed in the baroque style, retains a sense of grandeur and opulence, despite these days being little more than a shell. Built between 1724 and 1729, Sutton Scarsdale Hall was once anything but the relic it has since become. The brainchild of Nicholas Leake, 4th Earl of Scarsdale, the hall was designed as a statement mansion, intended to impress and to rival – if not exceed – the outstanding country homes already standing in the vicinity, such as Chatsworth House and Hardwick Hall. Whether this ambitious design brief delivered on its objective is open to debate, but what is unarguable is that Sutton Scarsdale Hall must have been a fine sight indeed at its zenith.

Aesthetically, the interior is known to have been particularly sumptuous, with exquisite features mirroring the statement and quality of Sutton Scarsdale Hall's impressive outer façades. However, the ambition that raised Sutton Scarsdale Hall to the heights it briefly enjoyed would ultimately be its downfall and its demise, and subsequent abandonment would be a painful one.

Nicholas Leake may have succeeded in creating a great hall, but he would die bankrupt in 1736, just seven years after the hall's completion. The knock-on effect and aftermath would be significant, with the heirs to the Scarsdale estate hampered with depleted funds and eventually forced to sell the property in the nineteenth century. At this point, the hall transferred to John Arkwright, a descendent of famed Cromford-based industrialist Richard Arkwright, who in turn passed Scarsdale Sutton Hall to an asset-stripping company in 1919, thus sealing its fate.

When it comes to abandoned, derelict buildings there is often a perception that these places disintegrate gradually over time; yet, in the case of Sutton Scarsdale Hall, it must have been quite a sight watching its interior being hastily dismantled and stripped of its contents. Internally, the hall's rich assets were removed and spread far and wide to surprising and exotic locations. A significant amount of its inner sanctum, for example, was exported to America; three rooms are currently on display at the Museum of Art in Philadelphia. One of the hall's pine-panelled rooms can be found at the Huntington Library in California, offered by a Hollywood producer who had used it on the set of the 1934 motion picture *Kitty*, having acquired it from newspaper tycoon Willian Randolph Hearst. Not even the roof was spared, ripped off for its lead in 1919.

Yet the final stage of the process – the full demolition of Sutton Scarsdale Hall – never actually happened. By now a shadow of its former self, the ruined hall was in fact saved by writer Sir Osbert Sitwell, who purchased what remained of the property in 1946 and saved it from full demolition.

These days, the site is under the stewardship of English Heritage, which continues to undertake crucial restoration work to safeguard its future. The result of Sutton Scarsdale Hall's complex, riches-to-rags tale is a rare spectacle. Visually,

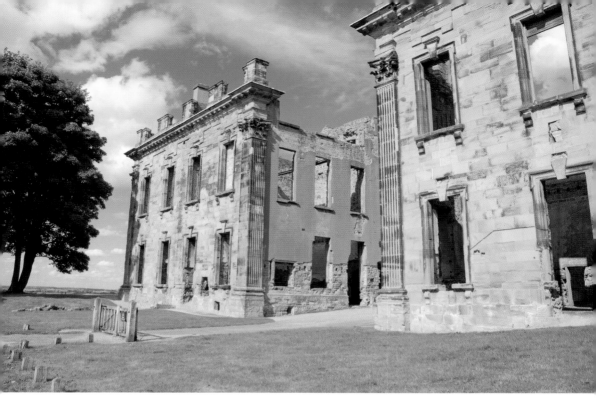

Above: Despite being ruinous, Sutton Scarsdale Hall retains much of its architectural integrity. (Gary Wallis)

Right: Sutton Scarsdale Hall's interior, the opulent possessions once housed here long since gone. (Gary Wallis)

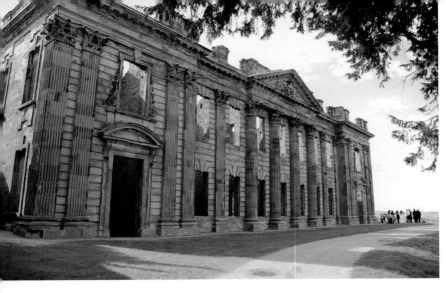

The hall's outer shell remains elegant and impressive, despite being stripped of almost all its assets over a century ago. (Gary Wallis)

it represents a dilapidated – albeit imposing – building, which isn't particularly any more striking than any number of historic grand houses across the country which met a similar fate. Yet with its skeleton intact, it offers fascinating insights into a once awe-inspiring interior, where intricate design work within the stone survives and the layout remains largely as it once was.

Sutton Scarsdale Hall's story is dramatic and ultimately sad, one of ambition and over-reach that could not be sustained. Despite all this, even in its current state, the landscape feels all the better for having the hall standing proudly on top of the hill.

Hardwick Old Hall

It is testament to the vision, ambition, influence and ingenuity of Bess of Hardwick that such a magnificent Tudor hall would become superseded by a still-grander structure just a stone's throw away, leaving the former largely redundant as the years passed by.

Built between 1587 and 1597 on the site of her birthplace, Old Hardwick Hall was a physical representation of Bess, one of Elizabethan England's most influential and wealthy women. Radical and innovative at the time, its creation in the twilight years of the Tudor period came as a result of the well-documented and acrimonious breakdown of Bess' marriage to her fourth husband, George Talbot, 6th Earl of Shrewsbury.

After leaving Chatsworth for her family estate at Hardwick, Bess, by now an old lady (especially by Tudor standards) set about developing firstly Hardwick Old Hall and then the newer Hardwick Hall, which remains in superb condition and receives thousands of visitors a year from around the world.

While the fortunes of the old and new halls at Hardwick have taken very different paths, it's a common misconception that the still-prospering new hall

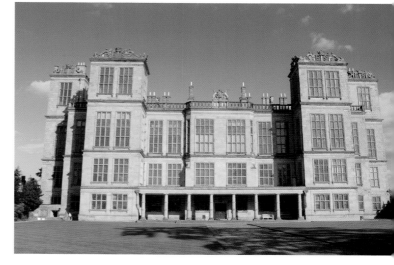

Above: The ruins of Hardwick Old Hall. (Gary Wallis)

Right: Hardwick Hall, the more illustrious and well known of the two, has fared much better than its ruinous neighbour. (Gary Wallis)

was designed to take the place of the old one. In fact, there was a point in the 1590s when both remained under construction. The consensus is that the new hall was built to be the statement property, designed to show off Bess' standing and status.[5] This extravagance, vision and grandeur, the handiwork of renowned architect Robert Smythson, led to the famous rhyme 'Hardwick Hall, more glass than wall.'

Old Hall, meanwhile, was intended to offer a more lived-in, comfortable environment, allowing Bess to spend her final years in luxurious comfort. The two halls were, to all intents and purposes, like two complementing wings of the

same magnificent building. So why did the Old Hall witness such decline that it now stands in partial ruin? Upon Bess' death in 1608, her heirs, the Dukes of Devonshire, grew to prefer Chatsworth to Hardwick. Indeed, Chatsworth is still owned and lived in by the current generation to this day. Subsequently, in the middle years of the eighteenth century, Old Hall was partially dismantled, with some of the materials used to supplement the dukes' other properties, and it fell into gradual and steady decline until reaching a ruinous and abandoned state.

There are plenty of examples of the hall's once glorious past as host to one of England's most successful women. Much of the original plasterwork and intricate designs survive. It remains a fitting and enduring tribute to a life well lived.

With the estate having been taken over by the National Trust in 1959, and subsequent renovations undertaken through the years, Old Hall remains a must visit for anybody with a penchant for historic buildings. There remains much to marvel at here, not least the viewing platform in what was once the Great Chamber, allowing greater scrutiny of this once stunning home. The upper floor, too, affords stunning vistas of the sprawling countryside, as well as a view across to the more famous and visually striking Hardwick Hall, which stands a matter of feet away.

Old Hall, once the residence of Elizabeth Cavendish (later Talbot), better known as Bess of Hardwick. (Pygarian Nox)

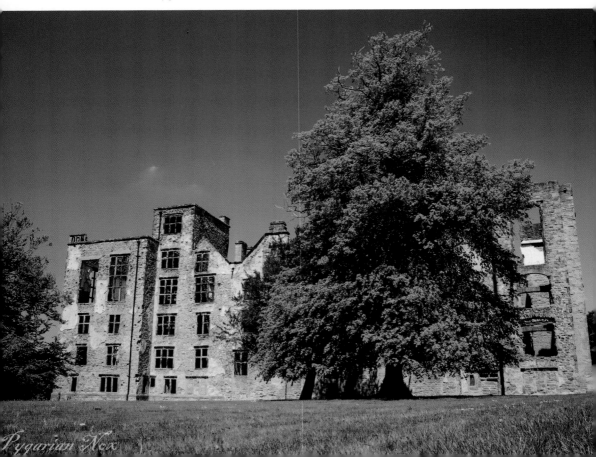

3

Derbyshire Dales

Magpie Mine

Despite having closed in the 1950s, the disused spectacle of Magpie Mine still stands in seemingly good condition on the site it has occupied for more than 200 years near the Peak District village of Sheldon.

The earliest reported workings at Magpie Mine date back to 1740, at which point it would have been one of many in the heavily mined area of the Peak, worked by thousands of local men.

From a distance, the mine looks commanding in its surroundings. The famous scenery of the Peak behind it remains largely unspoilt and hasn't changed a great deal since the miners plied their trade there. Such a scene of natural, unchanged beauty juxtaposed against a man-made industrial relic makes the site a favourite for photographers. Get up close, however, and it becomes clear that Magpie Mine is a melting pot of structures and machinery, each offering pointers to different phases of its past. These include arguably the most visually impressive element, the Cornish Engine House, and the adjacent and striking circular chimney, dated 1869 and 1840 respectively.

A distinctive square chimney, also built in 1840, survives, although the winding engine it was built to serve is long gone. Also visible is the main mine shaft, which drops 72 feet into the depths where water still runs. This chimney, alongside a

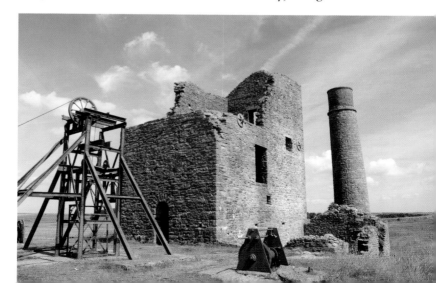

The remains of
Magpie Mine.
(Gary Wallis)

nearby flue, had been at risk and labelled vulnerable, subjected as it was to the often harsh natural elements. However, substantial renovations undertaken in 2016, aided by a grant from the National Lottery, ensure their presence continues.

The mine's collective legacy is a complex one, its fortunes ebbing and flowing through generations of miners who worked in this demanding setting. Multiple times the mine was closed, multiple times it reopened. Innovations, such as a Newcomen type pumping engine, installed in 1824, helped address the perennial issue of keeping water from the workings, resulting in 800 tonnes of lead being extracted in 1827, a record that stood for forty-four years. Yet just eight years after this record-breaking year, the mine was closed and while it would later reopen and be relatively prosperous – albeit never again on the same scale – this period would mark a seminal and sombre moment in its long history.

For many years, disputes had raged between rival mines, all competing for the same natural resources in the area. These were difficult times and each miner, with a family to support, had a vested interest in ensuring the mine they were working prospered. A particularly febrile and long-running dispute existed between the workers of Magpie Mine and nearby Maypitt Mine, both laying claim to the rich veins of red soil that ran underground. Unfortunately, these disputes were not limited to minor arguments in the local inns. Disagreements escalated, resulting in very real, and ultimately tragic, consequences as workers took it upon themselves to mark their perceived territories. This often took the form of lighting underground fires, started to 'smoke out' workers at the rival mine. This unfortunate act of aggression came to a head in 1833 when three workers from

Surviving horse gins, once used to wind the lead ore to the surface. (Gary Wallis)

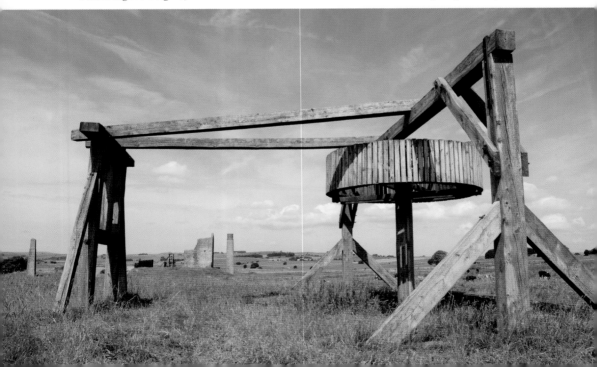

Maypitt Mine were killed, dying of fumes inhaled as a result of a fire allegedly started by Magpie Mine workers. As a result, twenty-four miners from Magpie Mine went on trial for murder, with all subsequently released without charge due to the seemingly impossible task of identifying who exactly lit the fire. The court also took into account the role of the Maypitt Mine workers in what had been a protracted and two-way dispute and rivalry. Naturally, the wives of the men killed felt a great injustice with the wholesale acquittals and, legend has it, put a curse on the mine that remains in place to this very day.

Just two years later the mine closed and would not reopen for more than 100 years – abandoned, only to enjoy a brief encore the following century. While way past its heyday, Magpie Mine limped on well into the twentieth century in various guises, eventually closing its doors for the final time in 1954 after a number of largely unsuccessful ventures, certainly in comparison to the prolific and productive years of the previous century.

These days, Magpie Mine perfectly taps into its history, renowned as one of the best surviving lead mines to be found anywhere in the country – over half a century after the last miner emerged from its depths and more than 280 years since the first went below ground.

Through numerous renovations, this iconic site, which achieved Scheduled Monument status in 1974, has weathered vast changes and threats to remain integral to the fabric of not just Derbyshire's mining history and heritage, but that of the UK's. Preserved by the Peak District Mines Historical Society, Magpie Mine remains accessible to the public – although for obvious reasons it isn't possible

Now a relic, Magpie Mine was used to mine lead for over 250 years. (Gary Wallis)

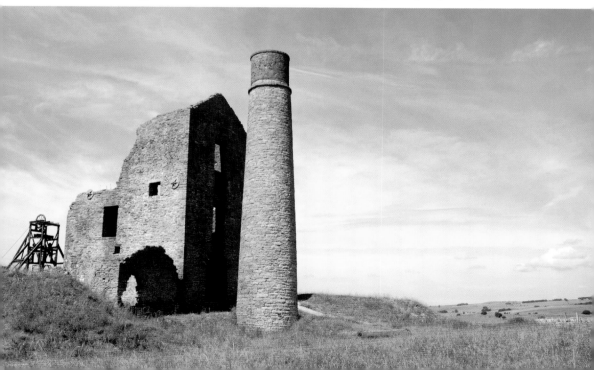

to access the underground workings – with guided tours on heritage open days available to help keep the stories and history of the site alive. The sprawling buildings associated with the mine, such as the agent's house and smithy, have been sympathetically renovated and repurposed and are now used as the field centre for the society.

Magpie Mine could never have continued in perpetuity and, like all structures of its kind, the day would always come when it would be rendered obsolete. Three decades after it closed its doors the mass closure of collieries, resulting in the nationwide Miners' Strike, would see many more mines follow suit. However, it is nevertheless a success story. A proud, if occasionally tragic, history has been replaced with a newfound purpose: that of educating visitors about Derbyshire's industrial past and offering inspiration for generations to come to become engaged with their local heritage.

Lumsdale Valley

Head to the peaceful Lumsdale Valley near Matlock and at first glance it's hard to imagine this scenic ideal with its babbling brooks, trees and flourishing fauna and flora was once a bedrock of the county's industrial landscape. Now a popular location for walkers and those looking to escape into nature, the valley – managed by the charitable Arkwright Society – was a busy working site in the 1700s and 1800s, with the sound of industry drowning out the gentle, calming murmur of flowing water and overhead birdsong that has since replaced it.

Lumsdale's rich industrial history and archaeological importance stems largely from the embarrassment of riches it possessed, lending the area perfectly to Industrial Revolution Britain. So unique is the area that Lumsdale was scheduled as an Ancient Monument in 2014 by Historic England.

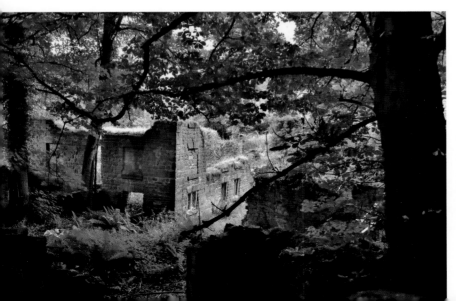

The ruined mills, squeezed into the narrow ravine, are slowly returning to nature. (Ian Bartley)

Benefiting from Bentley Brook, which used to power all the mills that once dominated, this harnessing of water power made Lumsdale, despite its relatively small size, a real asset from as far back as the sixteenth century, with work continuing until 1930. By this stage, however, the area was long past its peak in terms of output and productivity, having reached its height in the mid nineteenth century.

Stroll through the Lumsdale Valley and chances are that evidence of the area's past will soon present itself. Dotted around are no fewer than six mills, all in various states of ruin and all with a different story to tell. The wider conservation area – which currently extends to just over 90 hectares – hosts a number of listed buildings, including the 'at risk' former malthouse at Baileys Mill.

A meander from the top of the valley, the site of the first of three dams, offers a treasure trove of abandoned structures to discover, starting with the site of Bone Mill and continuing down past Pond Cottages (private residence), Saw Mill, Paint Mill and Corn Mill. Towards the bottom of the valley lie the Upper Bleach Works, Tramway, Smithy, and Lower Bleach Works. Millstones can be found scattered

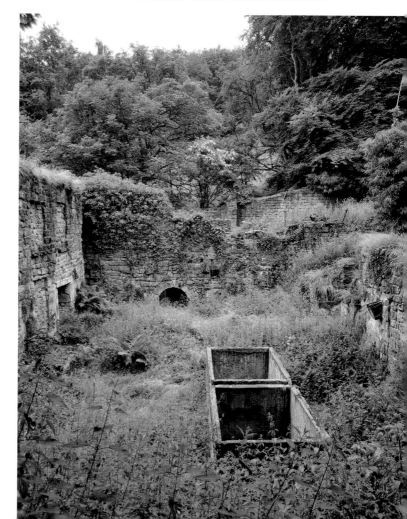

The old Corn Mill site, Lumsdale. (Lost Places & Forgotten Spaces)

around the area, while a stone trough, once used for bleaching yarn, still stands by the Paint Mill. Elsewhere the remains of a train track can be seen, which once linked the Lower and Upper Bleach Mills – both built in the early 1700s. Likewise, a number of bleaching vats, as well as the smithy, cling on, the bleaching vats believed to be the last surviving examples in the country.

Lumsdale Valley, with its picture postcard ponds and cascading waterfalls can be enjoyed independent of the history that forms such a strong part of its appeal. But these monuments certainly enhance the backdrop, providing a wonderfully unique atmosphere – an outdoor museum to Derbyshire's past industrial glories.

That this pretty and historically significant area endures is in no small part thanks to a previous landowner who, despite receiving offers for the in-demand stone that are such key components of these precious buildings, refused any advances, ensuring Lumsdale's mills are left in peace and protected to blend into the woodland that has slowly enveloped them.

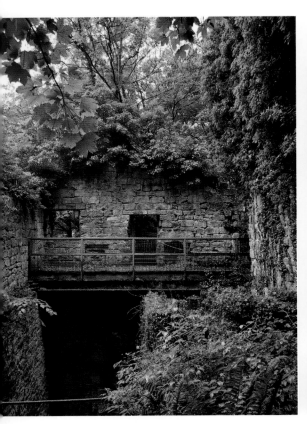

Above left: Inside the old Paint Mill. (Lost Places & Forgotten Spaces)

Above right: Evidence of the valley's industrial heritage is never far away. (Helen Moat)

Many of Lumsdale's structures, while cared for admirably by the Arkwright Society, are nevertheless in ruins and unsafe to enter or climb. Showing them the respect they deserve and need will hopefully ensure they remain an integral part of the valley for generations to come.

Bateman's House

Lathkill Dale, close to the Peak District town of Bakewell, is littered with ruined mines. Arguably the most interesting of these derelict buildings is Bateman's House, which hugs the River Lathkill, just downstream from another long-since abandoned structure, Mandale Mine, of which ruins still remain.

Bateman's House has a fascinating and intriguing past. Originally built in the 1830s by the Lathkill Dale Mining Company, its purpose was as strategic as it was practical: to hide from prying eyes the installation of an innovative water-powered pump to drain water.

The 12-metre shaft under Bateman's House, providing an entrance to the dark and damp depths where the pump would have been housed below, still survives. How successful this novel pump proved to be (if it was at all) is open to debate, although by the 1840s it was no longer operational, which suggests it probably didn't have the desired or intended effect.

As well as preserving the company's secrets from nearby competitors, Bateman's House also later doubled up as the family home for James Bateman (hence the

A water-powered pump, long since gone, was once housed beneath Bateman's House. (Gary Wallis)

name) who was an agent for the mining company from 1836 until the closing of the mine in 1842. Was this a genuine family home where he and his family enjoyed living or was this simply an effective way to have the site occupied 24/7 as a means of preventing industrial espionage? Either way, what is clear is that a dilapidated stone building nestled in a rural haven that once hid a mine shaft while doubling up as a family home is a unique set of circumstances indeed.

These days, Bateman's House is in such a state of ruin that it's hard to envisage that this was once a lived-in home and a shield for a fiercely guarded piece of machinery. Approach it, though, and you will find a useful and enlightening illustration on one of the inner walls showing how the building would have once looked, long before time and neglect took a terminal toll. Inside the shell of the building, look carefully and evidence of its past remains. Despite much of the walls having long since disappeared, window foundations can be found – surprisingly largely intact – while a stone hearth where a fire would have once roared is easy to make out.

The remains of Bateman's House. (Gary Wallis)

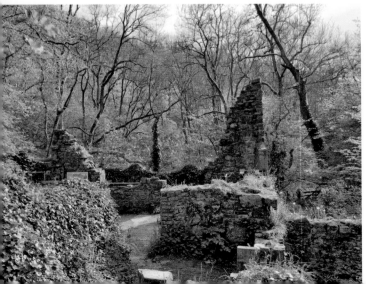

Once a family home, Bateman's House has been abandoned for many years and is now in a state of ruin. (Gary Wallis)

Bateman's House was anything but the sorry-looking structure it is today. Lathkill Dale Mining Company hoped it would play a role in safeguarding its future, giving them a competitive advantage in an often-cut-throat environment, while family life and everything that entails was played out within its walls.

Nowadays it sits barely disturbed, a relic to a former age and inconspicuous among the nature and wildlife that freely overruns it. Easy public access to the site courtesy of English Nature (now Natural England), together with a plaque and illustrations, ensure the quirky and unusual Bateman's House lives on, even if unrecognisable from what it once was.

Haddon Tunnel

It's not surprising that a tunnel designed specifically to not be seen when it was fully operational is even more inconspicuous now – over half a century since it was last in use.

During the arguably halcyon days of train travel, passengers could enjoy a scenery-rich journey from Buxton in the High Peak, through the Peak District countryside, calling at Millers Dale, Monsal Dale, Great Longstone, Hassop, Bakewell, Haddon, Rowsley and Darley Dale before terminating at Matlock. Long-since disused, remnants of this once-popular line can still be found, notably in the form of the Monsal Trail, now a popular walking and cycling route. However, below the hills of the stunning centuries-old Haddon Hall estate, near the town of Bakewell, lies a far less well-known part of the line, and one that leaves barely a trace on the landscape – as had always been the intention, even when it was operational.

When in the late 1850s and early part of the following decade the Midland Railway were planning this particular line ahead of construction, they encountered a not insignificant challenge. This issue centred on a section of the line intended to run straight through the unspoiled Haddon Hall estate, with Charles Manners, 6th Duke of Rutland, unhappy at the prospect of a train line dissecting and impacting on the estate's historic natural landscape. A compromise was reached, which would see an underground tunnel constructed that would allow the train to run below, but crucially not through, the estate.

On 10 September 1860 initial work began on the tunnel and by January 1862 it had officially opened for public use – a 1,058-yard tunnel buried beneath the estate and, either side of its openings, undetectable to the naked eye. At 7.20 a.m. on 1 August 1862, the first train roared through, 'running to a temporary terminus at Hassop, three miles away. Buxton was connected in May 1863'.[1]

The construction of this underground tunnel was a success – albeit additional work on it would be required from time to time in the years that followed – but it came at a cost. On 2 July 1861 an arch towards the northern section of the tunnel gave way with no prior warning, resulting in the tragic deaths of five workers,

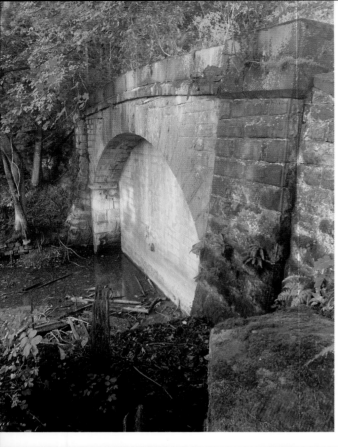

Left: The entrance to the tunnel, which once saw trains roar through with regularity. (Cath Turkington)

Below: The tunnel has been without purpose since 1968. (Mark Day)

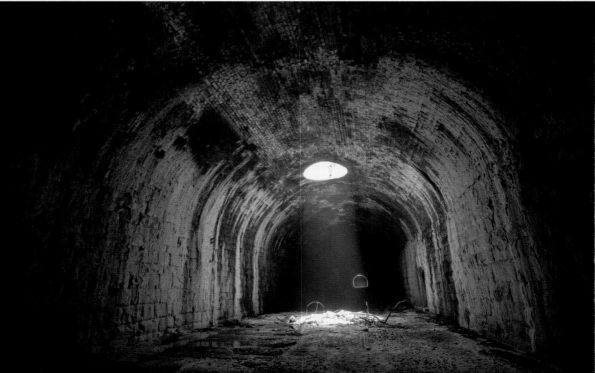

with a further two injured. The bodies of those who died were taken to nearby Bakewell. The next day, hundreds of locals visited the site to pay their respects and a memorial to those that died still stands in the churchyard at nearby Rowsley.

What can be seen, if anything, of the now forgotten tunnel below Haddon? The tunnel was built with five ventilation shafts – more than originally planned – which were necessary to allow steam to escape above ground. A wander through Haddon Hall's medieval park, made even more accessible through the introduction of excellent official guided walks in 2021, presents the opportunity to view these ventilation shafts among the unspoiled landscape the 6th Duke was so keen to protect. Closed off by metal bars to ensure safety, it's still possible to peer down into the dark to get an idea of the scale and depth of the disused tunnel that lies abandoned below.

Some 106 years after the first train entered the tunnel, it was the 1H18 from St Pancras to Manchester Piccadilly on 29 June 1968 that had the distinction of becoming the final train to thunder through. The tunnel has been silent ever since.

Upon closing, the infrastructure was dismantled and the tunnel bricked up. While not open to the public it remains largely intact, a well-preserved yet largely forgotten example of the Peak Rail's glory days. How many people have walked directly over it down the years soaking in Haddon's magnificent hall and its own extensive past, unaware that this relatively recent part of the estate's history is even there?

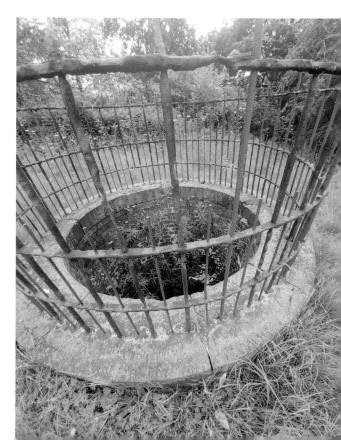

One of the ventilation shafts can still be seen above ground. (Nathan Fearn)

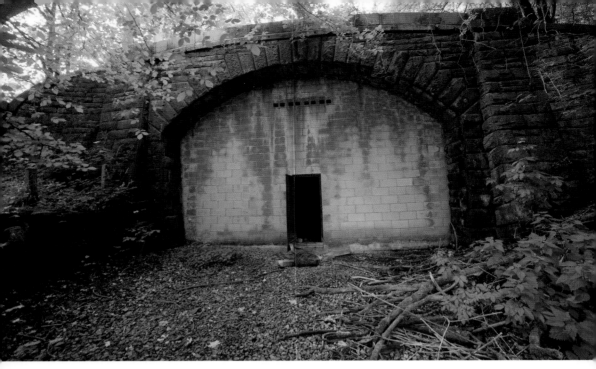

Where once a wide opening allowed trains through, access is now restricted to a small door. (Mark Day)

Bole Hill Quarry

These days, Bole Hill Quarry, situated in upper Padley above Grindleford in the Peak District, feels a million miles from what it would have looked like in the early twentieth century. Peaceful, teeming with wildlife, awash with impressive silver birch trees whose leaves provide a canopy from up high and steep natural gorges make for a walker's paradise and a place ideal for quiet reflection. Yet, in 1905 close to 500 people were employed here and in place of what is now stillness and quiet would have been a cacophony of noise from the 12-ton, 7-ton and 5-ton cranes that operated, not to mention the presence of a winding drum, locomotives and no fewer than 100 tipper waggons.

In a curious mirror image of the makeshift 'Tin Town' of Birchinlee covered earlier in this book, tin huts for workers were also erected here, albeit on a smaller scale. A further connection exists with Derwent, Ashopton and Birchinlee, as some of the stone quarried here was used in the creation of the Derwent and Howden dams.

It was also a place of tragedy, with reports of deaths among workers in the days before rigorous health and safety protocols. On 4 July 1904, the *Sheffield Star* reported on the death of a fourteen-year-old worker, stating that 'the boy's father saw the incident and fainted at the dangerous sight'.

National Trust estimates suggest that, pre-production, the quarry contained 2.4 million tons of building stone, of which around half was removed during the life of the quarry, with operations coming to an end in the middle part of the twentieth-century.

Nowadays, plenty of clues point to its former use. Grindstones can be found in plentiful supply, scattered around the large woodlands and open ridges with most camouflaged by the moss that has slowly engulfed them as the years have passed by. Curiously, some of these immensely heavy millstones appear neatly stacked side by side in rows, as if they have been meticulously placed together or abandoned before being put to use. Was this by chance or design?

The remains of an old pulley at the head of a gradual but deep gorge can still be found and a straight track that runs through an otherwise dense area of trees is almost certainly the route locomotives would have taken, carrying rock out of the quarry.

Down at the bottom of the quarry, by the old chapel in stunning Padley Gorge, a couple of worker huts survive.

Incidentally, Totley Tunnel, a few hundred yards away next to Grindleford station, was opened just over a decade before work at the quarry commenced and, at 3.5 miles in length, it is one of the UK's longest tunnels, running from Grindleford all the way to the outskirts of Sheffield.

The sounds of the past are difficult to imagine, given this area of mesmerising natural beauty's newfound state of serenity, but, thanks to grindstones so synonymous with the Peak District and various other artefacts, the many walkers and climbers that explore this area can easily imagine it.

Bole Hill Quarry has long since been abandoned, but it has been reclaimed by nature in a most stunning and aesthetically pleasing way. It is now in the hands of the National Trust, which has looked after and maintained the site since 1954.

Millstones point to the area's past industry. (Nathan Fearn)

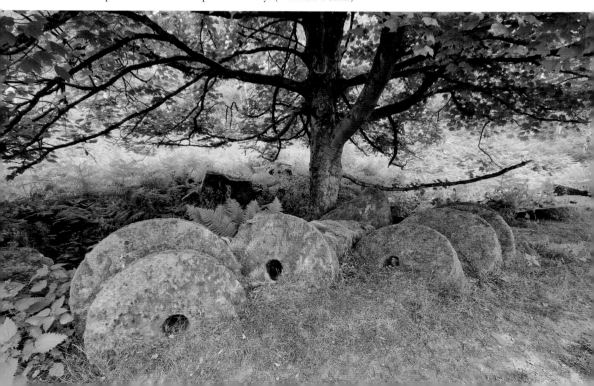

Left: A straight clearing among silver birch trees indicate where a temporary train line would have once been. (Nathan Fearn)

Below: Ruinous remains at the bottom of Bolehill Quarry, near Padley Gorge. (Nathan Fearn)

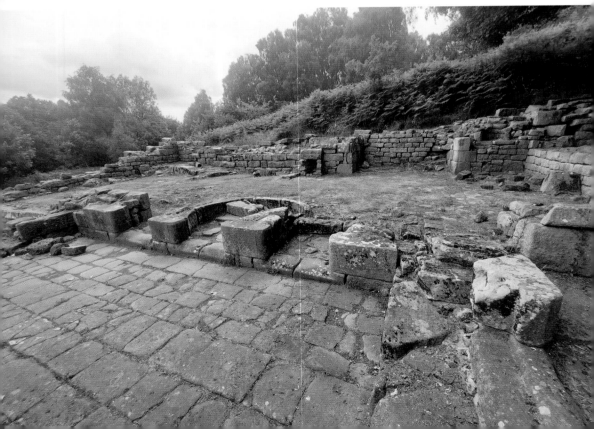

4

Amber Valley

Oakhurst, Ambergate

The once grand Oakhurst House in Shining Cliff Woods, Ambergate, has the rather depressing distinction of having never really been wanted by its intended residents.

The brainchild of wealthy industrialist and politician Francis Hurt (1801–54), a figurehead of the influential Hurt dynasty most commonly associated with nearby Alderwasley, Oakhurst was the product of both practical thinking and Hurt's desire to ensure his four daughters would be secure upon his death.[1]

It's a curiosity that despite the Hurts' astonishing success at marrying into upper echelons of well-established and influential Derbyshire families in the 1700s and 1800s, including the Gells of Wirksworth, Strutts of Belper, Harpurs of Calke Abbey and Arkwrights of Cromford, the four daughters of Francis Hurt remained unmarried throughout their lives – rare in such times.

As grand as Oakhurst undoubtedly was in its heyday – the house is described as being a 'fair-sized country mansion' with 'accommodation for twenty-four'[2] – it was never destined to be a happy nor loved home, not by the Hurts anyway.

Originally a forge house, Oakhurst was renovated by Hurt to the tune of £1,000 – clearly a significant sum at the time – and leased to iron master William Henry Mold after his father and former iron master Charles Mold had died there, pre-renovation, in 1846.

Mold occupied Oakhurst and the accompanying forge until 1859. By this point, Francis Hurt was dead and his four daughters – Fanny, Emma, Elizabeth and Selina – had long since made their intentions clear that none of them wished to move into the property their father had envisioned for them. Fanny Hurt, who appears to have been the most eccentric of the four, chose to live on her own after leaving Alderwasley Hall in 1854, while Emma, Elizabeth and Selina moved into Rock House, Cromford, which had formerly been the residence of Richard Arkwright up to his death in 1792.

When Mold's time at Oakhurst came to an end in 1859, the coming years became a precursor to what would ultimately follow. For almost two decades the mansion house stood unused, remaining under the ownership of the family, but redundant as a residence. However, Oakhurst would benefit from a renaissance and, indeed, go on to grow in stature before its eventual demise.

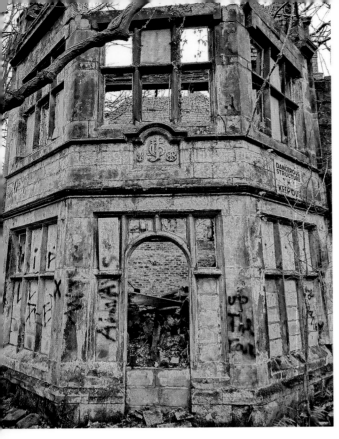

Once a grand house, Oakhurst is now in a state of almost complete ruin. (Lost Places & Forgotten Spaces)

Having left the hands of the Hurt family in 1888, Oakhurst passed to the Midland Railway, where extensions were made in order for the company's chief engineer to make it his residence. Five years later it was to change hands once more, this time purchased by Thewlis Johnson, the nephew element in Ambergate-based Richard Johnson and Nephew Wire Works Company, which had set up a base on the site.

Oakhurst took on numerous forms and incarnations in the decades to follow but did at least find stability in ownership, remaining in the hands of the company for the next 103 years until Bridon, which had taken over Wireworks in 1990, itself closed in 1996.

In Thewlis Johnson, who would reside there until his death in 1896, Oakhurst appears to have enjoyed a period of good fortune. Johnson, like Francis Hurt, was highly influential in local circles and turned the forge next to Oakhurst into a successful subsidiary of Richard Johnson and Nephew – Ambergate Wire Works. It was he who extended Oakhurst considerably, resulting in the neo-Jacobean Arts and Crafts style that it resembles today, albeit it in a highly dilapidated state. His imprint on the house, in the form of his stone-carved initials, still survive.

Certainly, evidence from the early parts of the twentieth century show a mansion that appears well loved and thriving, standing proud and resplendent within the woods.

Above left: A bricked-up door and sign discourages people from entering what is now an extremely vulnerable site. (Lost Places & Forgotten Spaces)

Above right: Plans were afoot in the 1990s to demolish Oakhurst; yet, thirty years on, it still (just about) stands. (Lost Places & Forgotten Spaces)

By the 1920s Oakhurst was benefiting from both its peaceful, secluded location and convenient transport links and the area evolved to become a place of solace, with Oakhurst House providing a focal point. Specifically, it became a retreat for the Diocese of Southwell, with the largest room on the second floor even transformed into a chapel. The property was later utilised as a summer school and even a conference venue. However, international forces indirectly brought an end to Oakhurst's days as a rural paradise.

Following the fallout of the Second World War, the mansion began a new phase of its colourful existence and was subsequently once again modified: this time divided into flats to house workers of the wireworks at a time when housing was in short supply. However, time was catching up with Oakhurst and by the 1970s its increasing wear and tear was beginning to show. This, coupled with more readily-available housing options as the post-war recovery continued, saw its residents moved on and placed in alternative accommodation. Never again would Oakhurst be used or inhabited in any meaningful way and over the past half a century it has fallen further and further into disrepair and now appears unsalvageable from a restoration perspective.

Left: Oakhurst has stood unoccupied for over half a century. (Lost Places & Forgotten Spaces)

Below: The exterior of Oakhurst. (Debbie Jarrett)

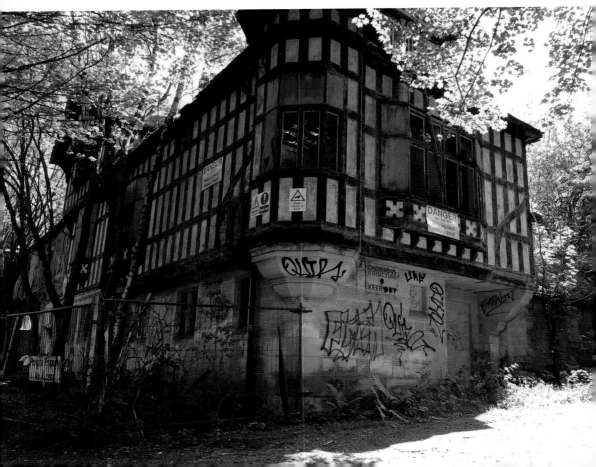

In 1994, plans were put in place to demolish the house; however, that permission has since expired, meaning Oakhurst still stands in Shining Cliff Woods – abandoned, structurally unsound and rightly fenced off from the public. Largely out of sight and out of mind, it deteriorates further with every passing year, now far more famous for its current state than the varied and interesting days it once enjoyed.

Wingfield Railway Station

There's a certain romanticism that comes with rail heritage, not least in Derbyshire. The thought of a steam train meandering through rolling hills and countryside, white steam billowing up into the sky, can often bring with it a sense of nostalgia for a utopian period that may not in reality have ever truly existed. Whether it's a former line now closed, a village station, or a particular locomotive – think the Flying Scotsman – rail history seems to uniquely resonate on our shores, and Derbyshire is no exception.

Wingfield station is curious in that while it has, until 2023, been disused and derelict since 1967, the Derby to Leeds line that it once served remains operational, now forming part of the Midland Main Line. This means that should you visit to pay homage to this important site, you may witness the peace and quiet and apparent abandonment punctuated by the sound of a train roaring through;

Wingfield railway station has become a shadow of its former self. (Derbyshire Historic Buildings Trust)

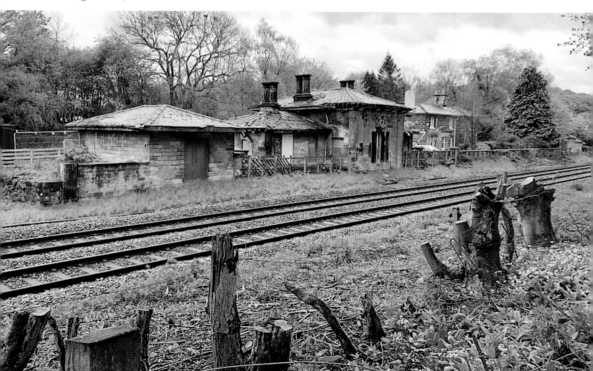

although these days there is, of course, no chance of one stopping at the disused platform to collect passengers.

Having served the area from 1840 for the next 137 years, the station, built by North Midland Railway, has the distinction of being the last remaining Midland railway station designed by renowned architect Francis Thomson, and is one of the oldest preserved of its kind anywhere in the country.

Condemned by Lord Richard Beeching's 'The Reshaping of British Railways' report of 1963, as so many up and down the country were, Wingfield station closed to passengers in 1967. Such is its historical significance, though, it was granted Grade II listed status in 2015.

Despite being a place of pilgrimage for rail aficionados and enthusiasts and widely acknowledged for its rare characteristics, Wingfield station nevertheless spent decades on Historic England's Heritage at Risk Register – first appearing in 1971. In 2012, it was also identified as one the ten most threatened Victorian and Edwardian structures in the entire country by the Victorian Society.

Inside, the building had appeared in recent years every bit of its 180-plus years. Perhaps most evident and striking, the once-busy booking hall fell into a state of severe disrepair, with much of the roof having collapsed in on itself. The rest of the

Wingfield station closed to passengers in 1967 and has declined steadily as the decades have passed by. (Derbyshire Historic Buildings Trust)

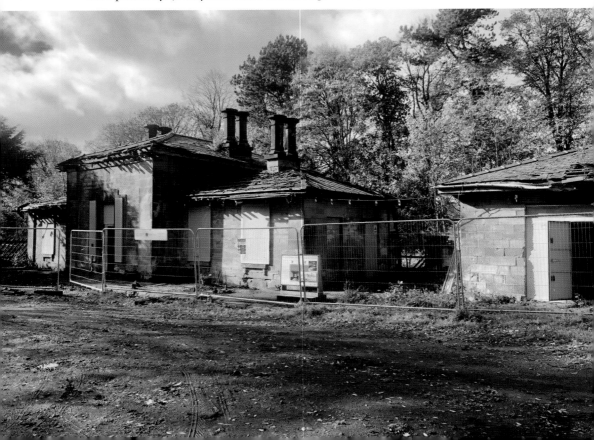

structure fared little better through years of neglect, although evidence of halcyon days remained – including the original stove in the porter's room and an original safe that would have once held travellers' money and valuables. The original wallpaper from the mid-nineteenth century in what was the female toilets, meanwhile, was discovered, hidden under layers of more modern wallpaper, itself now generations old.

While many structures of this kind are condemned to demolition and subsequently disappear, Wingfield station's place at the forefront of railway heritage has seen a concerted effort to see it rescued – an effort that reached a happy conclusion in late 2023.

Following a compulsory purchase by Amber Valley Borough Council in 2018 due to the inaction of a previous private owner, plans, with the support of Historic England and wider funding, were put in place to restore the station and give it a new lease of life.

Further developments in 2019 saw Derbyshire Historic Buildings Trust take ownership of the building and, gradually, new life has been breathed into its tired foundations and it has been brought back from the precipice. It has subsequently been restored and modernised but very much in keeping with its illustrious past.

Described even back in Victorian times as a 'maimed beauty', this unique 1840s time capsule was officially reopened on 27 October 2023 by the High Sheriff of Derbyshire and the daughter of one of the last stationmasters of Wingfield.

The trust are, as of early 2024, actively seeking a tenant in order to provide income to safeguard the station's future but with the possibility of being open to visitors from time to time.

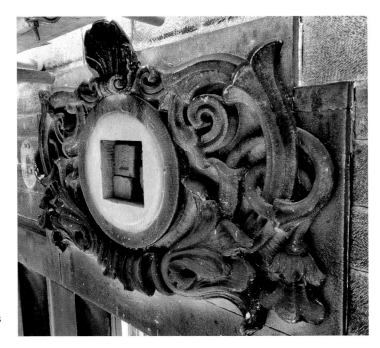

A trackside cartouche, which has fared much better than station house itself. (Derbyshire Historic Buildings Trust)

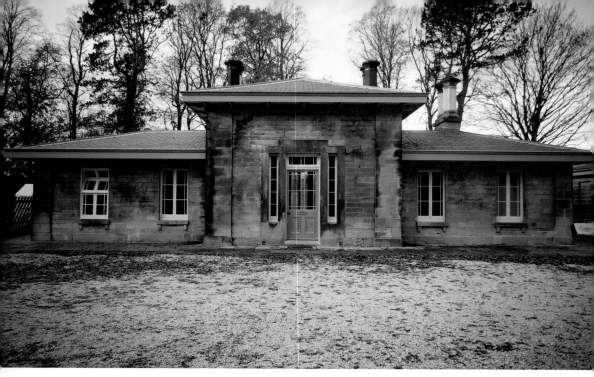

Wingfield station has been sympathetically but emphatically brought back from the brink. (Linda Singleton)

Heanor Grammar School

Heanor Grammar School is perhaps the antithesis of what one might expect an abandoned building to be. It's easy to assume most stand alone, forgotten about and far from view, sometimes unoccupied for decades, even centuries. But not only is the site that once housed Heanor Grammar School extremely visible – it stands on Mundy Street near the centre of the town – it has been far from forgotten about, with groups including the Heanor Grammar School Action Group and Friends of Heanor Grammar School advocating for the site's future.

Such passion for the building is understandable given it was a fully operational school as recently as 2013, with hundreds of students passing through its gates each year. This is a place where young minds were shaped and experiences shared, its connection with the town and surrounding areas remaining strong through the generations of locals educated there.

Originally founded in 1893 as Heanor Technical College, the building as it appears today was built between 1910 and 1912, designed by Derbyshire-born architect George H. Widdows at a cost of around £15,000. Opening its doors as the Heanor Secondary Technical School in 1912,[3] for sixty-four years it welcomed new tranches of students before becoming an annex of the then South East Derbyshire College in 1976 and, finally, Derby College in 2010.

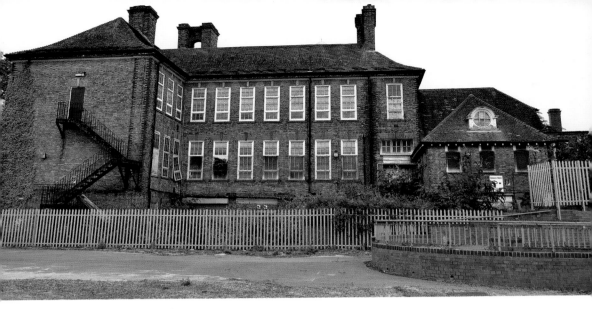

The exterior. (Ian Bartley)

Plans were afoot to continue the building's use as an education facility by transforming it into a studio college; however, ever-decreasing student numbers contributed heavily to this vision falling through. The site has been abandoned since 2013. The now deserted rooms and echoey corridors unintentionally pay homage to the building's former life. For former students, its current state of disrepair must evoke both nostalgia and a degree of sadness. A wooden plaque denoting former head boys and girls lies forlornly on the floor, while a lesson plan dated 11 March 2011 survives on one of the classrooms' whiteboards, more than a decade since it was written. Artwork produced by former students still hang to walls, while a sign warning students that an exam was in progress lies on one of the floors.

Other areas of the old school have fared particularly badly. Corridors are now marked with graffiti, the result of years of trespassing and vandalism, while one of the old toilet blocks has been reduced to rubble. However, not all of the school's historic assets are left to the mercy of vandals and the building's decaying environment.

Safe in the Derbyshire Records Office are a number of deposits made by the school through the years, including sixth form committee meeting minutes from 1967 to 1971, a group photograph of pupils from the 1934 academic year and a letter written by the upper sixth form to George Bernard Shaw sent on 12 November 1947 along with his reply, dated 27 December of the same year.

This Grade II listed building that once housed Heanor Grammar School may currently be abandoned but it remains firmly in the hearts and minds of many locals. Happily, during the final stages of writing this book, a significant development was announced pertaining to Heanor Grammar School's future. Now in the hands of Amber Valley Borough Council, which has acquired the site

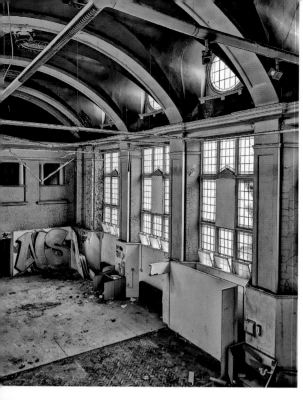

Left: Heanor Grammar School has suffered from both vandalism and neglect since closing in 2013. (Lost Places & Forgotten Spaces)

Below: Once busy corridors, now silent and still. (Lost Places & Forgotten Spaces)

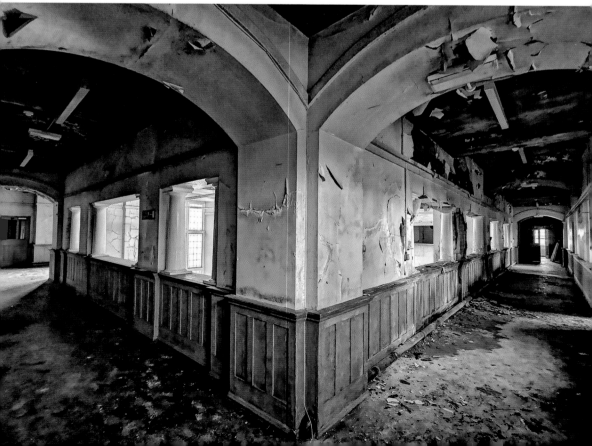

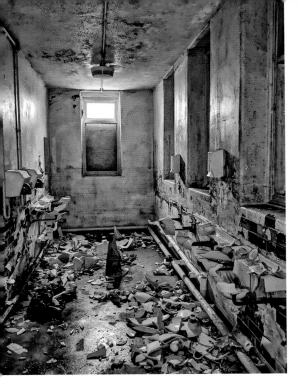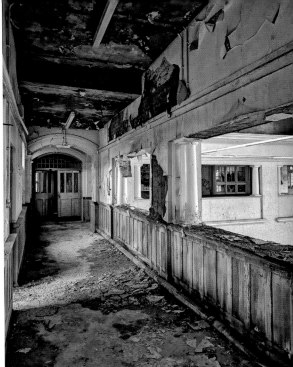

Above left: School toilets now in a state of ruin. (Lost Places & Forgotten Spaces)

Above right: Despite its severe dilapidation, it appears the building does still have a future. (Lost Places & Forgotten Spaces)

in support of its Future High Street project, this much-loved building, currently frozen in time, is to be 'restored and repurposed as a mixed-use development, with some work and business space, as well as community for local residents to use, preserving it for future generations'.[4]

Butterley Ironworks

In many ways, there are parallels between the current state of the once-mighty Butterley Ironworks and Heanor Grammar School. Both were central to their communities, both were once full of noise, hustle and bustle yet now stand silent, and both have fallen victim both to years of neglect and associated vandalism.

The Butterley Company, founded in 1770 by Alfreton-born pioneering civil engineer Benjamin Outram, was a constant presence at the now derelict site for more than two centuries, evolving with the times and widely regarded as one of the country's most advanced engineering companies.

Butterley Hall, incidentally, an eighteenth-century Grade II listed estate Outram also purchased, survives and has fared better than many of the sites and buildings

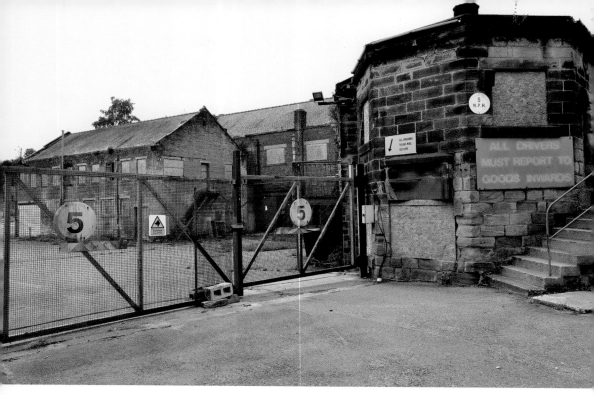

Locked gates and bordered-up windows at Butterley Ironworks. (Ian Bartley)

within the Butterley Works complex. It is now the headquarters of Derbyshire Constabulary and the county's Police and Crime Commissioner.

During its long and varied history, Butterley Ironworks was instrumental in the construction of St Pancras station in London and Vauxhall Bridge. Closer to home, the company was also responsible for the iconic Jubilee Bridge in Matlock Bath.

Tasked with supplying both weapons and military equipment during the First and Second World Wars, it played a significant role too in helping in the manufacture of pontoons used in the 1944 D-Day landings. Not that you would sense such an illustrious past from the way the site looks today. In fact, Butterley Ironworks, largely deserted since the company entered administration in 2009, citing the economic downturn, now feels distinctly eerie. Where once a culture of innovation, industry and ingenuity flourished, now stand crumbled buildings plagued by arson, vandalism and the reclaiming of nature as weeds grow unchallenged.

However, all is not lost. While some demolition work took place following the site's closure, the blast wall and disused former Cromford Canal tunnel cling on, recognised for their historic value and protected as a Scheduled Monument. Likewise, a number of the complex' buildings survive, including one in the yard – a hexagonal-shaped listed building that was the scene of an attempt by rebels to acquire goods from the site for weapons to advance their cause during the failed

1817 Pentrich Revolution. The rebels' quest was, however, unsuccessful, with the site's factory agent George Goodwin and a small number of constables standing their ground to repel the group.

There is hope that the site can be repurposed for community and/or commercial use, with local charity the Butterley Ironworks Trust advocating for it to be preserved and advancing the view that the site's surviving but frail features need both protecting and repairing. The trust also points out that some of the more significant surviving buildings, such as the underground wharf under the ironworks, which once had shafts up to the surface where blast furnaces were charged, are listed with Historic England, while one business retains a premises in the old Post Office building opposite the octagonal gatehouse.

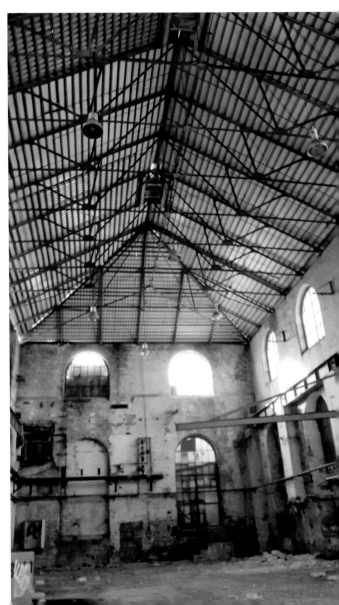

Inside the engine manufactory shop, part of the machine shop building. (Julie Webster)

For now, though, the overall site remains largely in a state of perpetual abandonment, certainly in comparison to its heyday, its rusting and decaying structures belying the great and influential force it once was. Yet, as we have seen with Heanor Grammar School, a degree of hope for its future remains.

Left: The blast wall, within which earlier blast furnaces lie, which produced some of the iconic ironwork used in the first cast-iron bridge at Vauxhall across the Thames. (Julie Webster)

Below: The Butterley Ironworks site from above in 1947. (Tim Castledine)

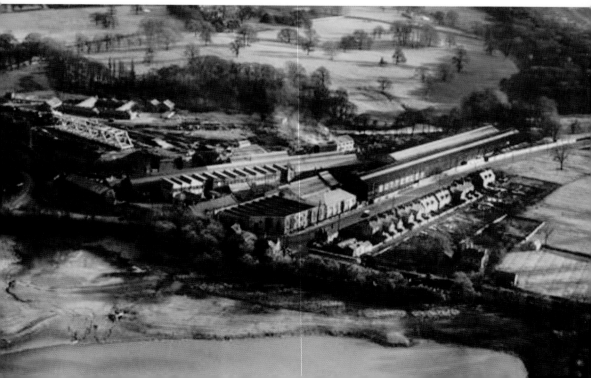

5

Derby and South Derbyshire

Derby's Underground Tunnels

Unbeknown to many who walk around Derby city centre, deep below their feet lies a subterranean world of tunnels, some of which date back as far as 1828, sprawling out from the Guildhall, Market Place and beyond.

These brick-lined routes have performed numerous roles in the many years they have existed below ground, evolving to meet the demands of the different eras they have been utilised in. One of the original purposes for this cold, dark labyrinth of tunnels was the storing of perishable goods such as cheese and meat in a time before effective chilling.

The tunnels run mainly between the Guildhall and the Tiger Coaching Inn, established in the 1200s and still in existence today in the form of the Tiger Bar, in which can be found an entrance to the tunnels.

Derby Guildhall. (Matthew Jones)

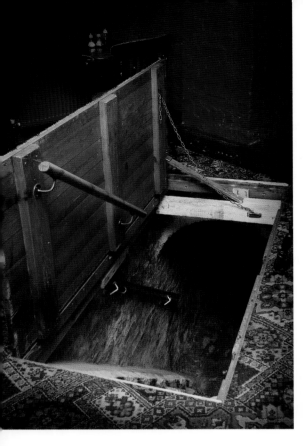

Entrance to the tunnels at Tiger Bar.
(Richard Felix)

However, these tunnels are perhaps best known for enabling the transportation of prisoners to and from trial away from prying eyes in the mid- to late 1800s. Their location, in this respect, was optimal.

Derby's first official police force was established in 1836, with the offices housed in the Guildhall. As well as facilitating secure passage for alleged criminals, prior to this, parts of the tunnels were also used as holding cells until the aptly named Lock Up was built.

In the 1870s, the underground network extended further, with a tunnel dug from Lock Up Yard (now widely referred to as the Fish Market) off the Cornmarket to link with the Guildhall tunnels. It was in Lock Up Yard that, in July 1879, Gerald Mainwaring shot twenty-six-year-old PC Joseph Moss, who in the process became the first serving policeman recorded as having been murdered in Derbyshire.

On his day of reckoning, Mainwaring was led through the tunnels linking the scene of his crime to learn his fate at the Guildhall, which has existed in various forms on the same site for more than 500 years. As well as the charge of murder, he also faced an attempted murder charge on the life of PC Price in the same incident. At his trial, Mainwaring was convicted on both fronts, serving fifteen years in prison before being released on licence in 1894. A modest plaque can be found in Lock Up Yard on the spot in which PC Moss fell, having been installed in 2002, 123 years after the murder took place.

Derby's underground tunnels also had a part to play in even more notorious criminal proceedings thirty-eight years on from the murder of PC Moss, when a 1917 plot to murder wartime Prime Minister David Lloyd George and a member of his War Cabinet, Arthur Henderson, was uncovered. It was alleged that this sinister plot, 'one of the blackest episodes in British political history', was hatched by Derby native Alice Wheeldon, the 'Peartree Poisoner' as she perhaps unfairly became known, at her second-hand clothes shop in Normanton, a suburb of the city.[1]

On 29 January 1917 the police, acting on dubious intelligence, arrested Alice as well as her two daughters and son-in-law. The night before the trial, they were imprisoned in the Lock Up before being escorted via the tunnel to trial – just as Mainwaring had almost four decades before. Here, she was remanded for trial at the Old Bailey for treason.

In the court Alice, a supporter of the suffragettes and a passionate anti-war campaigner, offered a glimpse as to what Derby's underground tunnels must have been like at the time. 'I hope we are not going back to the place where we were imprisoned last night,' she told the court. 'My feet have never been warm since I went there. The disgraceful state of the place and its coldness are a disgrace to civilisation.'

Alice was, as expected, convicted of the charge, although it was widely speculated in the years that followed that the evidence against her was not sound and that she had fallen victim to a calculated setup, designed to discredit the pacifist movement in a country still at war and in desperate need of keeping the public on side and on message.

Having embarked on a hunger strike that significantly impacted her health, she was released on licence in December 1917, although the grim experiences of her brief time spent underground in Derby appears never to have left her. Alice was reportedly never in good health again in the years that followed her experiencing those notorious tunnels and she died in Derby during the devastating Spanish Flu pandemic of 1919.

In 2013, Derby City Council and Derby Civic Society erected a blue plaque to her memory at No. 12 Pear Tree Road, Normanton.

The history of Derby's many underground tunnels, cellars, vaults and catacombs aren't restricted to criminal trials, however. During the Second World War, the Guildhall tunnels formed the central and largest air-raid shelters in the city. Not only did they provide sanctuary from German bombs, the sprawling complex and adjoining rooms were used for practical – if somewhat morbid – functions, such as storing flat-packed coffins in readiness for a major blitz on Derby, which, thankfully, never materialised.

Nowadays, evidence of these tunnels' former use can still be found – both above and below ground. On the main entrance between the Guildhall and Market Hall, for example, a painted sign on a door can still be found which reads: 'Keys to air raid shelters available from Mr Rose and Mr Gibbs in Derby Market Hall'.

Richard Felix, a Derby-born-and-bred paranormal historian who has appeared on numerous national programmes such as *Most Haunted* and *Britain's Greatest Haunts* has integrated the tunnels into his famed ghost walks around the city and arguably knows them more intimately than most. Yet only a third of the tunnels were accessible to the public during the period of these guided walks due to health and safety concerns, including four of the fourteen rooms still known to be in existence. Now, there is no access whatsoever to the general public, adding further to the mystique that surrounds them.

Some have argued that Derby's underground tunnels could become a valuable and viable visitor attraction in the future, although there are no concrete suggestions this could happen any time soon. One such advocate is Richard Felix himself: 'Derby's Guildhall has been at the hub of Derby's history for nearly 1,000 years. The tunnels are extensive enough to tell the whole of Derby's fascinating history,' he argues.[2]

> There are bricked up areas that need opening up and accessing, including the tunnel that leads from Derby Lock Up, under the corner of the Market Hall and linking with the Magistrates' Court in the Guildhall.
>
> For all we know the cells under the Lock Up may well still be preserved and there are three entrances/exits to facilitate the flow of people through the tunnels.

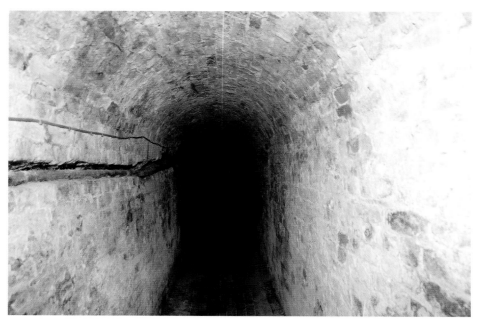

One of the underground tunnels included in previous ghost walks underneath the city. (Richard Felix)

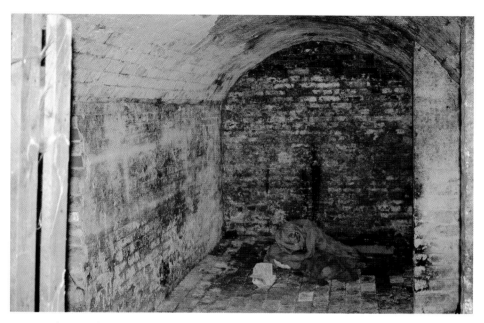

'Haunted' tunnels under the Tiger Bar, featuring a slightly unnerving dummy. (Richard Felix)

While there will undoubtedly be more discussions to follow, for now, the ghosts and memories of Derby's unseen tunnels remain largely undisturbed and forgotten, under the feet of the thousands who unknowingly walk above them every day.

As alluded to, some of the city's hidden tunnels, intriguingly, may still to be discovered. As recently as 2009 a long-since-forgotten passage was discovered behind a doorway in the cellar of the Ye Olde Dolphin Inne, believed to be the oldest pub in the city.

Derby Hippodrome

If the Derby Hippodrome Restoration Trust (DHRT) are successful in their long-running quest to bring this one-time giant of the city's entertainment scene back to former glories, this venue may yet look out of place in a book about abandoned Derbyshire sites, but the fight appears to be a long and complex one and, given the state of the structure, it would appear time is of the essence.

The sad and undeniable fact is that this baroque building, built in 1914, is barely recognisable in comparison to the one that welcomed significant and regular crowds at its height to enjoy performances from world-renowned stars such as Morecambe and Wise and Cliff Richard. In fact, its current state is, frankly, shocking.

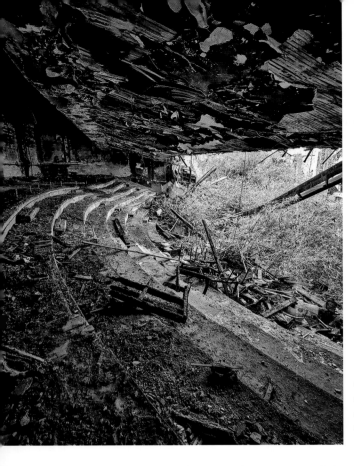

Once the place to enjoy acts such as Cliff Richard and Morecambe and Wise, the auditorium has since experienced a devastating decline. (Lost Places & Forgotten Spaces)

Culturally significant in that its original design was something of a hybrid – a dual-mix of live theatre and cinema – Derby Hippodrome was granted Grade II listed status by English Heritage in 1996. Just a decade later, it was added to the Theatre at Risk register.

Some may argue it has since gone past the stage of being at risk. As is depressingly common with buildings that have been left to decay, Derby Hippodrome has had to battle arson and vandalism on top of the natural and relentless degradation that continues to consume it.

Initially opening as the Hippodrome Theatre with a show entitled *September Morn* on 20 July 1914, just eight days prior to the outbreak of the First World War, the then 2,000-plus-seat venue was once the city's premier entertainment venue.

In those early days of the Hippodrome, Cinema Treasures, a group providing the world's most comprehensive guide to movie theatres from all eras, suggested that 'seating was provided on three levels: 1,000 in the stalls, 550 in the dress circle and 351 in the upper balcony … the squared proscenium opening is 38 feet wide and 35 feet high, it has a stage forty feet deep and ten dressing rooms'.

The Hippodrome went through a series of owners, modifications and modernising in the 1930s and remained a key cog in the city's leisure and

entertainment scene up to the mid-twentieth century, at which point its fortunes as a premier venue started to falter.

Societal changes, such as the increasing popularity and availability of television sets in homes, lessened the influence it had once enjoyed. With fewer people attending shows and subsequently a smaller pool of touring performers to take up residence, Derby Hippodrome closed its doors as a theatre on 31 January 1959 with the conclusion of the run of pantomime *Queen of Hearts*. The venue remained dormant for the next three years.

Reopening in a new guise, Derby Hippodrome opened its doors once more in 1962, this time as a bingo hall, which is how it would remain for a further forty-five years – exactly the same period of time it had existed as a performing venue previously. However, when the last bingo number was called on 26 January 2007 – almost exactly forty-eight years since the final performance of *Queen of Hearts* – Derby Hippodrome, already by that stage long past its glittering best, hurtled into a very quick downward spiral.

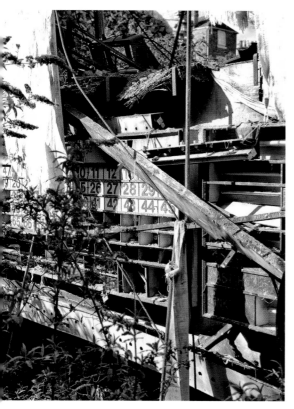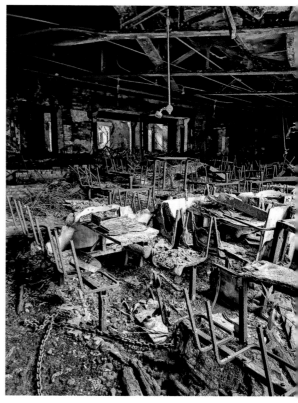

Above left: A bingo board remains amongst the ruins. (Lost Places & Forgotten Spaces)

Above right: 'Eyes down'. It's hard to believe in its current state that the venue was still hosting bingo nights as recently as 2007. (Lost Places & Forgotten Spaces)

Renovations in 2008 deemed 'essential' by the owners of the site only served to exacerbate its deteriorating state with the work condemned strongly by The Theatres Trust. Central to the issue was the removal of structural beams supporting the roof, resulting in colossal damage that left the theatre not only derelict but partially demolished.

Visit now, and the building is a mixture of the effects of vandalism and, many would argue, bad judgement calls, on top of the irrepressible force of nature of Japanese knotweed, a particularly invasive plant that took up unruly residence in what is now the un-roofed former auditorium. Still, some believe this site, steeped in history and heritage, has a future. 'The theatre has the potential to be rebuilt and restored to theatre use and could provide Derby with an elegant 1,000–1,200-seat theatre' argue DHRT.[3] Others believe the site is now an eyesore that needs to be torn down and redeveloped, given its prime location in the city.

Time will tell what the future holds for the once popular Derby Hippodrome, but for now it exists in clear sight in a seemingly unrelenting and alarming state of abandonment and ruin.

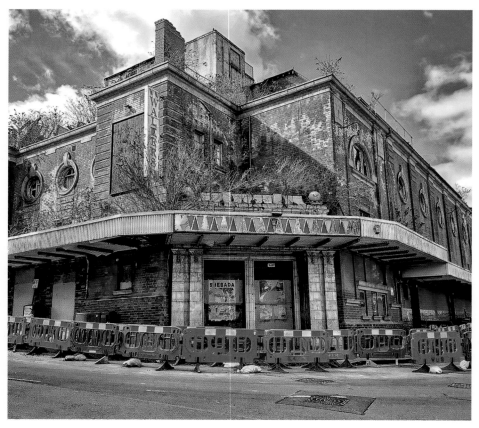

The dilapidated exterior of Derby Hippodrome. (Lost Places & Forgotten Spaces)

Calke Abbey

Set in magnificent grounds close to the picturesque South Derbyshire village of Ticknall, Calke Abbey qualifies as an abandoned building by virtue of the fact that, despite being a major visitor attraction, it remains largely unchanged since becoming uninhabited in the late 1800s.

Managed and maintained with great skill and vision by the National Trust, Calke Abbey – the 'un-stately home' as it has been branded by the trust – is a triumph of preserving the past in an extremely authentic way.

Standing on the site of a former priory dissolved in the reign of Henry VIII, as so many religious houses were during the Dissolution of the Monasteries, Calke Abbey is a stately home truly frozen in time where its abandonment adds, not detracts, from its charm and appeal.

In 1622 the estate was acquired by Sir Henry Harpur of the previously referenced Harpur dynasty, with the 1st Baronet of Calke Abbey purchasing the estate for the then eye-watering sum of £5,320. It would remain the seat of the Harpurs for the next twelve generations through nearly 300 years of ownership.

What makes Calke Abbey so fascinating from a socio-historical perspective is that each of the Harpur (later Crewe and then Harpur-Crewe) baronets who passed through the stately home over the years greatly influenced both its interior and exterior in very different ways. These range from the Enlightenment-influenced Sir Henry Harpur; the family focused and religiously devout George Crewe; to Sir Vauncey Harpur-Crewe, who showed commendable devotion to the estate he had inherited. These are just three of the former custodians who shaped what Calke Abbey ultimately became, and what it still is today.

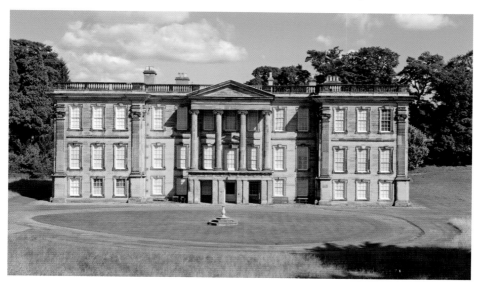

Calke Abbey today. (Gary Wallis)

The latter, Sir Vauncey Harpur-Crewe, was the final baronet at Calke Abbey before the title became extinct on his passing in 1924. Having embarked on a large modernisation of the estate, Sir Vauncey also amassed a huge national history collection including shells, eggs, insects and more. Today, Calke's natural history collection is the largest in the National Trust's possession.

At a time of crippling death duties, Sir Vauncey's death saw the estate pass to his daughter Hilda, who had to sell off a significant portion of her father's collection as a result. The following years continued the downward financial pressure. At the height of Calke's financial crisis, its owners were paying up to £1,300 a day in interest charges due to tax debt and the estate was forced to economise further to save it from going the same way as many of the grand houses that had suffered similar problems.

Yet this did not deter the family from further modernising Calke Abbey and the wider village, although by this point the evolution of the interior had ground to a halt, resulting largely in what we still see today: the estate passing into the hands of the National Trust in 1985.

Calke Abbey was, and remains, a medley of eras, influences and stories, yet the hall itself is largely as it once was, offering a tantalising and unique glimpse of what life must have been like in times gone by. Faded, peeling walls, decaying

A walk through Calke Abbey is like stepping back in time. (Helen Moat)

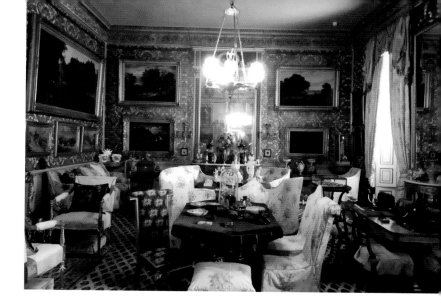

Interiors frozen in time. (Helen Moat)

architecture, dolls houses un-played with for more than a century, furniture with exquisite-yet-tired embroidery pointing to more prosperous times, stuffed mounted animals on the walls... Calke Abbey celebrates abandonment in a way that few other comparable large houses can match.

It's this very deliberate attempt to preserve the past that makes Calke Abbey so compelling, keeping it relevant and visible for future generations long after its heyday under the stewardship of the family with which it became so synonymous.

Old Hall, Littleover

The case of Old Hall in Littleover is a curious one. A building once essential to the communities it served, it now stands disused and unoccupied. Standing on a near-5-acre site on Burton Road, Old Hall, built in 1891 on what was once an Elizabethan estate, was erected for businessman Edward MacInnes and is best known for being the nerve centre of Derbyshire Fire & Rescue for forty-five years. Prior to that, this commanding Victorian mansion, later extended to incorporate sprawling outer buildings used as training hubs and office blocks, was in the hands of Rolls-Royce from 1954 to 1971.

Its public service days came to an end, however, in 2016 when the Derbyshire Fire & Rescue Service joined Derbyshire Constabulary at its headquarters at Butterley Hall, Ripley, where it remains today.

In some quarters it appears to be holding up well. Other than the empty car park and absence of people, should you be stood in the courtyard heading towards what was once the reception you'd be hard pressed to not believe this was still a functioning site. The reception area, complete with its heavy-duty wooden desk, remains in reasonable condition, the panelling behind it still displaying 'Derbyshire Fire and Rescue' signage, albeit the 'r' is now missing in 'Derbyshire' and the clock

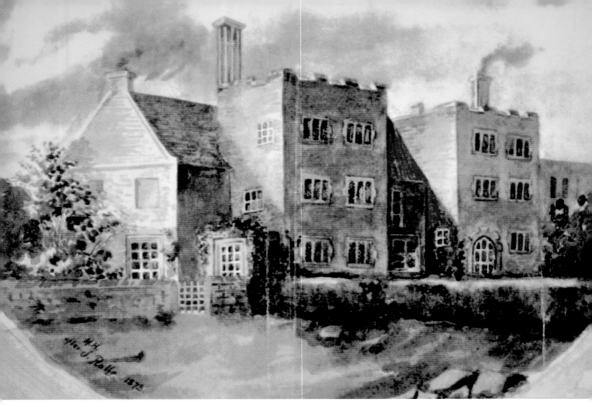

Old Hall as painted by J. Rolfe in 1873. (Maxwell Craven)

face that sits above it has lost its hands. Hallways and stairs appear, visibly at least, in good working order, the staircase's oak panelling still intact and glistening courtesy of the sunshine beaming in from the dust-filled windows above.

Yet Littleover's Old Hall is now far from fit for purpose – albeit by no means beyond redemption. Buckets sit in rooms to catch rain from leaking ceilings and plasterboard lies strewn on faded carpets, the result of ceilings that have become unstable and, in some cases, have collapsed altogether.

In the derelict outer buildings, much evidence remains of the site's former activity. Spinning chairs lie scattered, empty mugs sit on partly dismantled work stations, framed photographs of fire engines from various periods rest against walls and old posters advertising social events from 2014 remain pinned on notice boards. In the sports hall, details of the final badminton matches played there can be found on the whiteboards, which are still attached to the walls. It would seem these outbuildings' days are numbered, with plans afoot to redevelop the site for housing – although these plans do not include the Old Hall itself, whose future remains uncertain.

As time continues to gradually take its toll and erode a building so synonymous with Derbyshire life – from its earlier days operated by the iconic Rolls-Royce company to saving countless lives as the operational centre of the county's fire and rescue operations – it remains to be seen whether Old Hall is granted a new lease of life or falls further into obscurity.

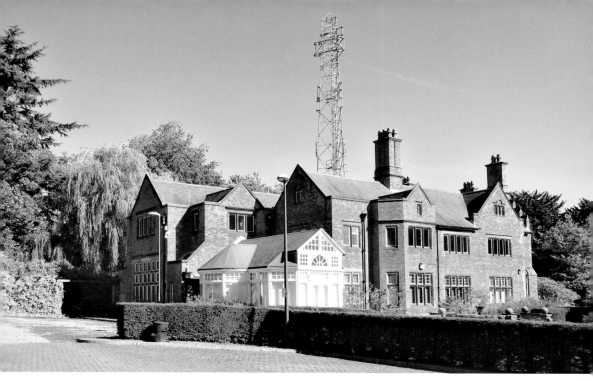

Old Hall as it appears today. (Maxwell Craven)

6

Reclaimed

Cromford Mills

It's alarming to think how close the world's first water-powered cotton mill came to being levelled to the ground and consigned to the annals of history. Yet had fate taken a different course, Cromford Mills, a sprawling complex developed over centuries, would have been lost. Gone with it would have been a hugely significant part of Derbyshire's – and the world's – industrial heritage. Fortunately, Cromford Mills' stay of execution has become a permanent one and it is now one of the jewels in the crown of the Derwent Valley UNESCO World Heritage Site.

It has certainly been on some journey. The original cotton-spinning mill was built on the site in 1771 by Sir Richard Arkwright, a founding father of the Industrial Revolution. Hugely innovative in its day and originally comprising five storeys – now three, following the loss of the top two floors to fire in 1929 – the mill formed the centrepiece of a prospering site that steadily grew, taking on more outer buildings in the years leading to the end of the eighteenth century.

Cromford Mill, the world's first water-powered cotton-spinning mill. (Ian Bartley)

Evidence of Arkwright's huge influence on the area can still be found in abundance. His name remains immortalised on the distinctive, red-bricked outer walls of nearby Masson Mill, while in Cromford itself the rows of houses built for the mill's workers in 1776 survive. They are widely considered to have been the first factory housing development in the world.

Cromford Mills is not alone. Today, all along Derbyshire's Derwent Valley, many of its mills cling on and stand defiantly amid a drastically altered landscape. South along the A6 (but still within the Derwent Valley UNESCO World Heritage Site) cotton mills in Milford and Belper, built by Arkwright's business partner Jedidiah Strutt, still dominate the skyline. Further south still, Derby Silk Mill, the site of what is widely acknowledged as the world's first modern factory, dating from 1721, is now the award-winning Museum of Making, a celebration of Derby's – and the wider Derwent Valley's – rich history, heritage and game-changing contributions to the industrial age.

The 50-mile River Derwent, a catalyst for so much of the county's development and industrial output, had been pivotal to the success of Cromford Mills, but water disputes around 1840 drastically limited the site's capacity and production levels.

While neighbouring Masson Mill continued to maintain a level of prominence for some time to come, surviving correspondences between essayist and historian Thomas Carlyle to his brother provides further evidence that, by the middle of the nineteenth century, Cromford Mills' influence was on the wane, Carlyle noting that 'the Mother of all the Mills [*sic*] very nearly fallen silent now, likely soon to out altogether'.[1]

Even during its heyday, the site had been in a constant state of flux. A second mill was built in 1776 but burned down in the following century, with later buildings taking the place of where it once stood. Today, only its foundations and waterwheel pit survive.

Between 1840 and 1922 the Cromford Mills site lurched from purpose to purpose, including spells as a brewery, cheese warehouse and even a wash laundry.

Despite its renewal, the site remains authentic with plenty of evidence of its former life. (Ian Bartley)

However, it was after Cromford Colour Works vacated the site in 1979 following a fifty-seven-year residency that the site arguably faced its biggest crisis and threat to its future. For many years as part of its operations, the company had produced colour pigments for paints and dyes and, upon leaving, many of the buildings' fabrics were discovered to be suffering from unsafe levels of contaminates, including lead chromate and arsenic.

By this point there appeared a growing consensus that the buildings making up Cromford Mills were so far gone structurally, and that the site was so far removed from its original purpose, that its practical and historical value was lost.

'It was generally believed the mills had reached the end of their useful life and must be demolished – all the key buildings had fallen into disrepair and many of the historic features of the site, including the principal watercourse, had been obliterated by modern development,' muses the Arkwright Society.[2] 'So degraded had the site become that the Local Authorities believed it had lost too much of its original integrity that it was no longer historically important.'

Against this backdrop, it would have been easy for the site to have been stripped totally beyond recognition and all its heritage lost, especially given the health

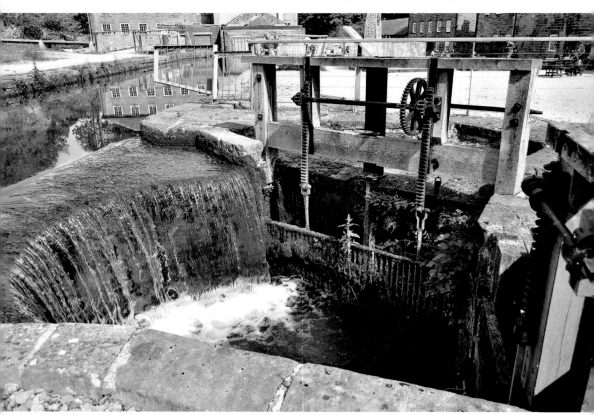

Relics of a bygone age at Cromford Mills. (Ian Bartley)

and safety concerns surrounding buildings that had once constituted one of the world's largest and most internationally-significant factory complexes.

It is testament then to the Arkwright Society's vision and fortitude that a site which had once been at the cutting edge of innovation, technology and industry but which had regressed to such levels of neglect and decay was deemed salvageable.

The society – born out of the Arkwright Festival Committee created to facilitate and celebrate the bi-centenary of the mill in 1971 – bought the rundown site in 1979 and set about a long and difficult restoration process, the results of which have ensured that Cromford Mills has been saved, enhanced and future-proofed.

Following numerous ambitious redevelopments, it now boasts an array of attractions from a popular visitor centre and the Arkwright Experience inside the original 1771 mill, to a variety of independent shops, cafés and more, which utilise many of the old mill buildings.

The road to reprieve for Cromford Mills has been long, arduous and at times fraught with complexity and danger. Yet now, thanks to a multi-million-pound restoration with support from the Heritage Lottery Fund, visitors can enjoy a protected and rejuvenated Grade I listed complex with World Heritage status. Its days of abandonment are, happily, behind it.

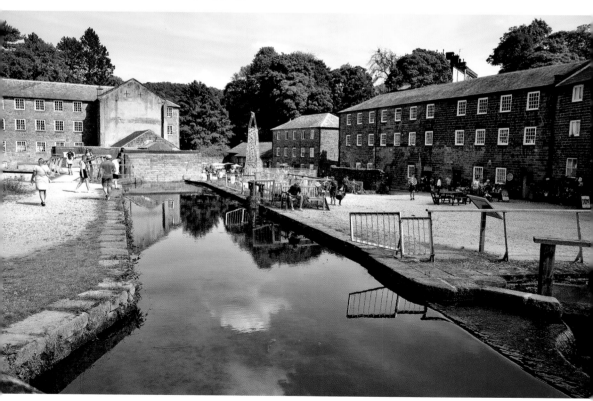

The site has since been repurposed and is a thriving visitor attraction. (Ian Bartley)

Saltergate, Chesterfield

Old-fashioned football grounds, usually comprising traditional terraces, four stands and four corners with floodlights towering over them, are becoming rarer with each passing decade as they become superseded by newer stadiums more suited to football in the modern age.

Many of today's football stadiums follow a similar pattern: bowl-like in appearance (rather than the traditional four-stand design) and built with multi-purpose use in mind in order to maximise 24/7 revenue opportunities, such as year-round conference and banqueting facilities. In short, they're impressive but arguably lack the character and soul of bygone grounds where crowds would pack the terraces and be so close to the action they were almost on the pitch.

Saltergate, the former home of Chesterfield Football Club, is one such example of a ground that had character and history in abundance but was simply no longer fit for purpose, as was Derby County's Baseball Ground, which ultimately experienced a similar fate.

Officially called the Recreation Ground, the Spireites' home was located just off the town centre, the focal point of a residential area consisting of tightly packed terraced houses. It hosted its first football match on 4 November 1871, contested between Chesterfield and Rotherham United, making Saltergate one of the country's oldest football grounds prior to demolition.

Comprising outdoor toilets, a wooden kop, unseated terraces behind the goal, large, towering floodlight pylons, a traditional supporters' club bar and a portacabin club shop in one of the corners, Saltergate wasn't for the faint-hearted, but it had a charm and an aura about it – much loved by generation after generation of loyal supporters who religiously attended at 3 p.m. every other Saturday.

However, after 139 years of history, the crowds filed out of Saltergate for the final time on an emotional afternoon on 8 May 2010 following a match against

Saltergate, former home of Chesterfield FC, in its final years. (Tina Jenner)

The ground once hosted more than 30,000 people for a cup match. It is now housing. (Tina Jenner)

Bournemouth. Fittingly and somewhat poetically, Chesterfield claimed a 2-1 victory in dramatic fashion with an injury-time winner. With that, a ground that had once hosted 30,561 spectators for a single match against Tottenham Hotspur in the FA Cup back in 1938 was no more.

Supporters had, at least, had some time to get used to the idea. As the club moved into the twenty-first century it had become clear that both the ground, as well as its limited hospitality facilities, needed a serious upgrade. Despite proposals to redevelop the Spireites' spiritual home, a supporter ballot in 2006 came out in favour of relocating and the club subsequently moved to a multi-purpose, all-seater stadium on Whittington Moor, some 2 miles away, ahead of the 2010/11 season.

As supporters acclimatised to their new home, Saltergate stood unoccupied, weeds steadily growing between cracks on the concrete terraces, and an already rundown ground gradually faded, although it did continue to be used for a short period by the club-affiliated Chesterfield FC Community Trust.

However, given its prime location close to the centre of town, Chesterfield FC's former home was never likely to be left indefinitely to decline. Proposals for the development of sixty-eight new homes were approved by Chesterfield Borough Council and, in July 2012, the final floodlight was pulled from the skyline. With that, the last-remaining part of what was the Recreation Ground was gone.

These days, you would struggle to imagine that a football ground once stood for 139 years on a site now occupied by modern houses. However, the name of the development – as chosen via a public vote – does at least give a nod to its past, with the estate called 'Spire Heights', a play on words of Chesterfield FC's nickname – the Spireites.

The site today. (Nathan Fearn)

Derbyshire Royal Infirmary

Remember the iconic white twin towers at the old Wembley Stadium? Despite their Grade II listed status, they were demolished in 2003 to make way for the new Wembley. Comparisons can be drawn between the old Wembley and today's (almost) demolished Derbyshire Royal Infirmary (DRI), which stood on what is now Bradshaw Way in the city's aptly named Nightingale Quarter. Both Wembley and DRI were superseded by newer, modernised structures and subsequently razed to the ground. However, unlike Wembley's twin towers, DRI's own iconic towers – its famous 'pepper pot' buildings – have survived.

The construction of Derby Royal Infirmary began with much fanfare, Queen Victoria symbolically laying the foundation stone on 21 May 1891, having given her permission for the new hospital – which officially opened three years later – to use the word 'Royal' in its name.

DRI was essentially a rebuild of a hospital on the same site, which had earlier suffered an outbreak of typhoid, an episode significant enough to warrant starting anew. One theory for the devastation that swept through the Victorian wards was that the hospital's design allowed the typhoid to run rampant. So it was that DRI's

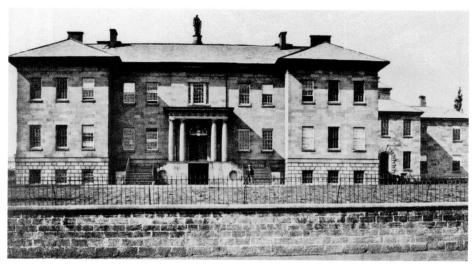

Taken by Richard Keene *c.* 1856 from London Road. The image shows the former hospital before being rebuilt as Derbyshire Royal Infirmary – note the lack of trees in front of the site, which were not planted until 1872. (Maxwell Craven)

A postcard showing Derbyshire Royal Infirmary *c.* 1915. (Steve Lilley)

striking north and south 'pepper pots' were designed to limit the risk of future disease outbreaks, rather than just being added for aesthetic reasons.

Having served the community for more than 100 years, by the turn of the millennium services gradually began to be transferred from DRI to the new Royal

Derby Hospital on Uttoxeter Road, the process reaching completion in 2009, at which point the last patients left the old site. This was followed by six years of abandonment in which the building gradually declined, its deserted corridors and desolate wards frozen in time and the sounds of a busy hospital replaced by silence. Photographs show empty beds and wheelchairs lying scattered haphazardly, children's toys caked in mould, discarded and outdated computer hardware sitting on rotting desks next to crumbling walls.

Despite being in a state of abandonment for a relatively short period of time from closure to demolition, certain areas of the site in the interim resembled something akin to an apocalypse film, as if everyone there had hastily left at a moment's notice.

In late 2020, however, five years after the site – bar the pepper pots – had been demolished and eleven years since the hospital had closed its doors for the final time, work began on a multi-million-pound redevelopment, making it one of the largest city centre regeneration sites in the UK.

All evidence of the hospital that had stood on the 18.5-acre site is now gone, other than the towers, which have been saved and are set to be given a new lease of life as an integral part of the new development, comprising mainly housing. Publicly available documents from the developer suggest these famous towers will be transformed into, among other things, a community café, exhibition and gym.

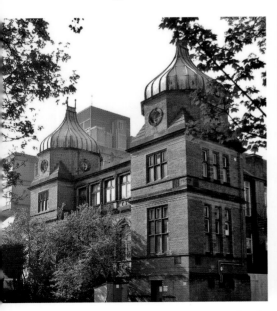

Above left: Derbyshire Royal Infirmary in 2011, pre-demolition. (Maxwell Craven)

Above right: A partly demolished DRI in 2017 taken from the successor hospital, with only the listed pavilions remaining. (Maxwell Craven)

The American Adventure

Few places of local abandonment have captured the imagination of Derbyshire natives more in recent times than the old American Adventure site in Ilkeston, which operated for three decades between 1987 and 2007. Even now, new articles from local and national media outlets on the park's fateful decline appear regularly, while phrases such as 'Is American Adventure abandoned?' and 'What does the American Adventure look like today' feature highly in online search results.

The haunting pictures that circulate of the abandoned park have given the site a sense of other-worldliness, almost as if its legacy now lies in what it became, rather than what it was – perhaps because the contrast between the two is so great. It wasn't always that way, however. For a number of years, the American Adventure was a popular and modern theme park attracting tens of thousands of visitors from across the country.

Despite its initial, and at first sustained, period of success and popularity, the park's star was on the wane from the latter part of the 1990s. By the turn of the century, the American Adventure was lurching towards terminal decline. In fact, when the park closed for the season in 2006 – never to reopen, unbeknown to the public – many of its flagship rides had already disappeared or were out of commission and the park was a shadow of what it had once been.

In January 2007 it was officially announced that the site would not reopen and what had once been a thriving theme park quickly spiralled into dereliction. Fast-forward to the site's final days in the early 2020s and the theme park resembled a

The Rapids in more successful times for the theme park. (Gary Wallis)

Assets rounded up ready for sale during an auction day after the closure of the park. (Chris Eyre)

ghost town, with once flourishing landmarks struggling to be seen, competing with overgrown weeds and untamed trees. Fast-food parlours bordered up, stripped of the colourful livery that once adorned them; gates padlocked, overcome with rust and decay; and broken windows in shelters where visitors once waited excitedly in expectation of entry were just some of the sights that would greet curious onlookers.

In 2017, a local petition to reopen the park was signed by thousands of people. While ultimately in vain, the attempt is testament to the fondness in which this doomed visitor attraction is still held, close to two decades since its closure. Indeed, a Facebook group with close to 2,500 members named 'The American Adventure Theme Park', providing a public forum for 'sharing the memory of the American Adventure' is still active, attracting regular contributions on a daily basis.

The remains of the theme park have now gone without a trace, a new housing development taking their place. Yet the sentiment remains.

If anything, The American Adventure's well documented sad decline into abandonment has only strengthened its legacy – the nostalgia of what it once was, and the shock of what it became.

Above: Pre-demolition, the site looked more like a ghost town. (Robin Spencer)

Below: An abandoned entrance plaza, a far cry from the site's heyday. (Robin Spencer)

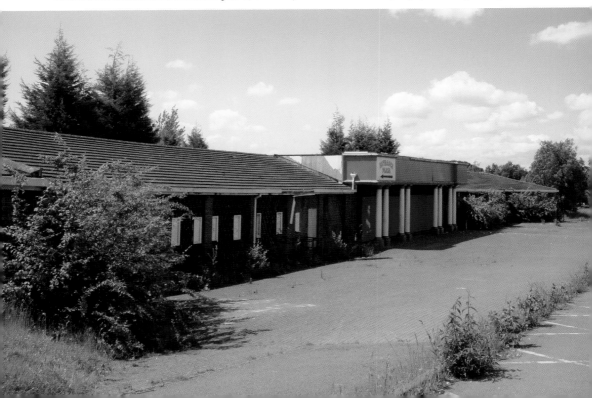

Honorary Mentions

During the process of writing this book, many places were considered and ultimately discarded for various reasons. Some missed the cut due to location; for example, where there was already strong representation in a certain area – such as Wingfield station taking precedence over Wingfield Manor. Others were considered, even included in early drafts, but dropped after research on other sites revealed compelling stories associated with them that could not be ignored. The following missed the final cut, yet all are fascinating and unique in their own right and warrant referencing here as honorary mentions.

Bailey's Tump

Found on Asker Lane at the top of Matlock on land once owned by a Mr Ernest Bailey – hence Bailey's Tump – this Second World War air-defence site was, for a long time, fairly inconspicuous after falling out of commission. Take a closer look, though, and earthworks and ruined buildings that acted as shelters for those operating anti-aircraft equipment are still evident.

Bailey's Tump certainly played its part during the war. From here a hostile Dornier Bomber was brought down in the winter of 1940, the plane eventually crashing around 10 miles west, near Great Longstone.

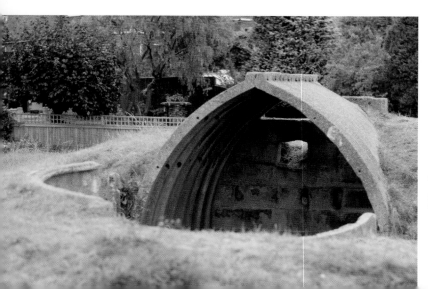

The restored remains of Bailey's Tump. (Ian Bartley)

Evidence of where Second World War anti-aircraft guns once stood, with Riber Castle in the distance. (Ian Bartley)

No longer required on the cessation of war, and with the machinery and soldiers gone, the area was abandoned and gradually began to blend back in with the nature surrounding it. However, the site was painstakingly restored by Matlock Civic Association between 2005 and 2008. In 2008 an opening ceremony was attended by around 500 people and included a flypast by a Lancaster Bomber.

An impressive plaque packed with detail now stands on the site, which affords commanding views towards Riber Castle and down into the valley, making it easy for those visiting to visualise how Bailey's Tump would have looked and operated in those dark and uncertain days of the 1940s.

Chesterfield Tunnel

Built in the late nineteenth century as part of a so-called Chesterfield loop following the extension of the railway line between Nottingham and Sheffield, the 474-yard Chesterfield Tunnel was the first landmark for those departing the old Chesterfield station.

It served the network for just shy of seventy-five years before a restructure of the railway network rendered it obsolete. Passenger services were suspended from the old station in March 1963, with the tunnel witnessing the last train steam through in January of the following year. It has remained abandoned ever since, while the station was demolished a decade later, replaced by an inner ring road in the town.

Modern transport infrastructure has left the once important Chesterfield Tunnel behind. It now stands largely forgotten and out of public consciousness – despite the tunnel's concrete air vent protruding from the ground and visible from the road offering evidence of its existence.

Not open to the public and with its entrance now behind locked gates, the years have taken their toll on Chesterfield Tunnel, which is bleak and dank inside and

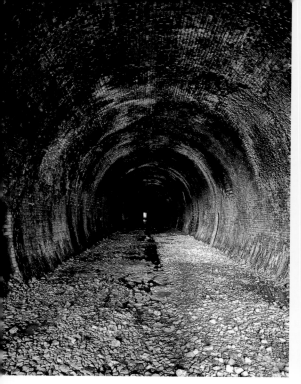

Above left: Chesterfield Tunnel today, the days of trains roaring through long gone. (Lost Places & Forgotten Spaces)

Above right: The tunnel is now abandoned and prone to flooding. (Lost Places & Forgotten Spaces)

prone to flooding. A relic to a bygone age, it seems hard to imagine trains packed with passengers roaring through the tunnel during a heyday that has long since passed.

Heath Old Church

An abandoned building within an abandoned village, Heath Old Church is the last remaining building in what was once the settlement of Loud (Lune in the Doomsday Book), which existed close to what is now Junction 29 of the M1 between Chesterfield and Mansfield. Loud is believed to have combined with Heath sometime in the thirteenth-century and the newer Heath All Saints' Church, built in 1852, stands a quarter of a mile from the ruins of Heath Old Church.

With the building of its successor, Heath Old Church was knocked down, with just the south porch – which still stands today in its original position – and south doorway of the nave surviving. Evidence of the window frame that would have once stood on the north wall also survives, although its original stained-glass window has long since disappeared. The remains of a small mortuary chapel –

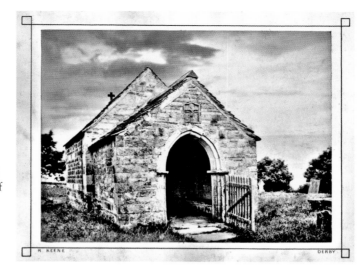

A print of a Richard Keene photograph of Heath Old Church, taken around the 1870s. It now lies in ruin. (Maxwell Craven)

built from materials from the demolished church and remaining in use until 1904 – also clings on although this, too, stands in a state of considerable ruin.

Further artefacts from the original church at Heath can be found at the nearby Heath All Saints' Church, with three of the five bells in the tower originally from its predecessor.

Pottery Methodist Chapel

Located on Kilbuourne Road, Belper, the two-storey former Pottery Methodist Church and adjoining Sunday school have lain empty for many years. The tired and dilapidated brick structures are now in a state of significant disrepair, but two plaques – one on each of the two buildings – point to happier days. They read: 'Pottery Methodist Chapel A.D. 1816' and 'Foundation stone laid by B. Spencer, Esqr. 1878'.

The 'Pottery' element of the name refers to Bourne's Potteries, which operated on the site prior to the construction of the church. Hugh Bourne, of the same company, was a founding father of Primitive Methodism and was likely influential in redeveloping the pottery works into a new place of worship for the people of Belper.

It's certainly sad to juxtapose the vision of children enjoying Sunday school and a congregation coming together each Sunday as a community to worship with the present-day state of the buildings, which now appear distinctly unloved.

It is also fairly unusual to see a historic, well-known and listed building gradually disintegrating in plain sight. Unfortunately, legal disputes have left Pottery Methodist Chapel frozen in time and growing less stable as the years pass. Its future remains uncertain.

Pottery Methodist Chapel in happier times, *c.* 1903. (Adrian Farmer)

Willington Power Station

Another abandoned structure whose future remains uncertain is the now decommissioned power station at Willington, south Derbyshire. Comprising station A and station B, construction for each took five years, reaching completion in 1957 and 1962 respectively. Willington Power Station provided energy for four decades. However, as the energy landscape changed and with the increase in privatisation, Willington began a gradual decommissioning process in the 1990s.

On 31 March 1999, unit six was de-synchronised, bringing to an end forty-one years of power generation at Willington. Demolition of the vast site was swift,

Below left: A sign to a work entrance that no longer exists. (Lost Places & Forgotten Spaces)

Below right: Willington's cooling towers still dominate the skyline. (Lost Places & Forgotten Spaces)

beginning towards the end of 1999 – a matter of months after the final unit had been decommissioned.

Yet by far the most prominent and striking elements of the power station, the monumental cooling towers, survived and continue to dominate the landscape to this day. However they now stand eerily unused and silent, the sky above clear where once huge plumes of water vapour rose from their depths.

For how much longer this stay of execution continues is open to question, with various development proposals debated in the years that followed the decommissioning.

The area where Willington Power Station once stood has at least been put to good use by nature. In the 1990s, rare peregrine falcons were found nesting on the former site, a phenomenon barely conceivable at its peak.

Wingfield Manor

As previously established, Bess of Hardwick was arguably, aside from Elizabeth I, the most influential and wealthy woman of the late Tudor era. Her vast wealth and status can still be seen in a number of her former Derbyshire residences, such as Chatsworth and Hardwick Hall, both of which have survived and thrived.

The same fate has not been afforded to Wingfield Manor, which back in the 1500s had served as an important and visually impressive structure. It was here that Mary, Queen of Scots, was held under house arrest in 1569, 1584 and 1585.

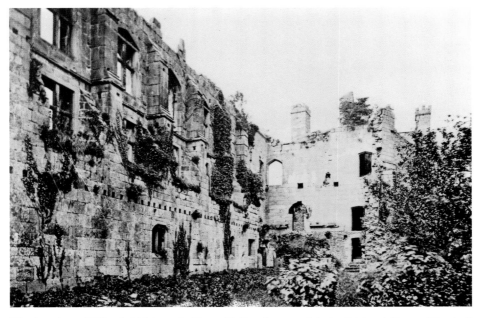

The interior of Wingfield Manor's Great Hall, taken *c.* 1865 by Richard Keene. The hall had been stripped some 100 years previously. (Maxwell Craven)

Built prior to the reign of the Tudors in the 1440s for Lord Cromwell, Treasurer of England, its impressive great hall and 72-foot-tall tower must have been some sight at its peak.

Interestingly, Wingfield Manor did not simply become gradually neglected and ruinous as many such buildings have done over time. Following the English Civil War of 1642–48 the manor was purposely partially demolished to ensure it would not be able to be used for defensive purposes, should another conflict arise in the future. Despite future restorations, the manor was completely abandoned in the eighteenth century and left to ruin, although much of the structure – and evidence of its former glory – still remains under the stewardship of English Heritage, while some of the area forms part of what is now a private working farm.

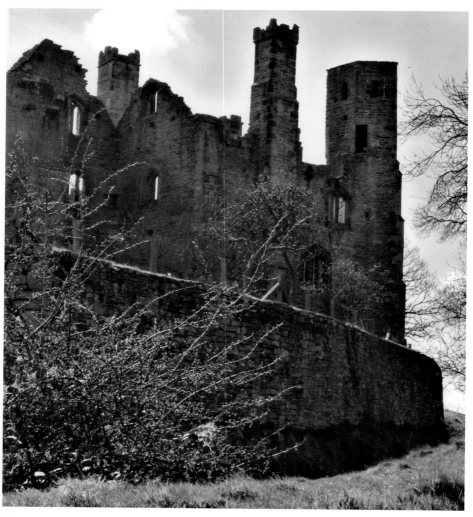

Wingfield Manor. (Maxwell Craven)

Useful Information

Please note that not every place featured in this book is open to the public, and even those that are may pose health and safety risks. It is recommended that, where necessary, research is undertaken ahead of any proposed visit to establish whether it is legal and safe to do so and, of course, private land should be respected.

High Peak

Derwent/Ashopton/Birchinlee: While these villages no longer exist, beautiful walks can be found around where they once stood, with Ladybower particularly popular. Information at visitpeakdistrict.com.

Errwood Hall: There are numerous parking options around Errwood Hall. For the full range of options, and additional information on walks in the area, visit goyt-valley.org.uk/directions.

A625 abandoned road: Roadside parking can be found for those wishing to take a look. Postcode: S33 8WA. More details at peakdistrict.gov.uk/visiting/miles-without-stiles/mam-tor-landslip.

***Over Exposed* crash site:** There is free layby parking near Pennine Way on the A57, but this can quickly fill up. Postcode: SK13 7PQ.

North East Derbyshire

Trinity Chapel, Brackenfield: Located west of Ogston Reservoir, Trinity Chapel's remains can be found in Trinity Wood at Ordnance Survey grid reference SK358593. More directions at brackenfield.org.

Seldom Seen Engine House: Parking is available in the nearby village of Eckington and there is a public car park behind the Bridge Inn, near Ridgeway village. Ordinance Survey grid reference: SK421800.

Sutton Scarsdale Hall: Entrance to this English Heritage site is free, although conservation work means only the exterior is available to view (as of 2022). There is a small car park via Hall Drive (postcode: S44 5UR). More at english-heritage. org.uk/visit/places/sutton-scarsdale-hall.

Hardwick Old Hall: A car park operated by the National Trust is five minutes by foot from the Old Hall. Postcode: S44 5QJ. Please check ahead of time for opening dates and times. Information at english-heritage.org.uk/visit/places/hardwick-old-hall.

Derbyshire Dales

Lumsdale Valley: According to the Arkwright Society, the permissive path that runs through the mill ruins at the middle of the valley is open Monday at 9 a.m. to Friday at 8 p.m. as of April 2022. It is closed at weekends and bank holidays to give some protection to the unique mill ruins. This does not affect any Public Rights of Way that run through the rest of the valley. More information at cromfordmills.org.uk/lumsdale.

Bateman's House: Parking is available around Lathkill Dale, notably at nearby Monyash at the top end of the dale, as well as at Over Haddon. The ruins stand on the south side of the River Lathkill, just east of nearby Palmerston Wood. Grid reference: SK 19436584.

Haddon Tunnel: A walk through Haddon Hall's medieval park (charges apply) will reveal the ventilation shafts. Car park available across from Haddon Hall for those visiting. Postcode: DE45 1LA. Further details at haddonhall.co.uk/visit.

Magpie Mine: Located close to the village of Sheldon, around 3 miles west of Bakewell. The mine sits on open access land and is accessible to the public. Roadside parking is available (DE45 1QU) but limited, although further parking options can be found nearby and in Sheldon.

Bole Hill Quarry: Grindleford station (postcode: S32 2HY) offers easy access to Padley Gorge and Bolehill Quarry. Parking available (cash only) or via an app. Trains run regularly from Sheffield.

Amber Valley

Oakhurst, Ambergate: Found in Shining Cliff Wood. The wood itself is easily accessed from the village of Ambergate, but Oakhurst is gated off with no access allowed and is a significant health and safety hazard. The derelict building lies close to Lockwood Haulage, Derwent Works (postcode DE56 2EL).

Wingfield Station: The station is easily accessible and located off the B5035 road, near the A615 at Oakerthorpe, north-west of Alfreton. Found on Old Station Road, South Wingfield, DE55 7NH.

Heanor Grammar School: Located on Mundy Street in Heanor town centre off the A6007 Ilkeston Road (postcode: DE75 7DZ). The site itself is not accessible to the public.

Butterley Ironworks: The most visible remains from the works' early days are in the north west section of the site, bounded by the Alfreton to Ripley road. Further details can be found at her.derbyshire.gov.uk/Monument/MDR7798.

Derby and South Derbyshire

Derby's underground tunnels: Not currently open to the public. Derby Gaol, however, found under Nos 50 and 51 in nearby Friargate, is open as a museum, providing a feel for Derby's underground network.

The Hippodrome, Derby: The premises can be found on Green Lane, Derby (postcode: DE1 1ES) on the corner of Macklin Street. While it can be viewed up close, the Hippodrome is private property and not open to the public.

Calke Abbey: Found in the south Derbyshire village of Ticknall (postcode: DE73 7JF). Parking available on site. Non-National Trust members must purchase tickets from the ticket office on arrival. Prices and opening times at nationaltrust. org.uk/calke-abbey.

Littleover Old Hall: Located on the aptly named Old Hall Road, Littleover (postcode: DE23 6GG). This is a privately owned site and not open to the public.

Reclaimed

Cromford Mills: Easily found along the A6 just south of Matlock. For satnav purposes, use postcode DE4 3SRQ. Parking available. Cromford Mills is a past winner of the Accessible Derbyshire Award. More information and opening times at cromfordmills.org.uk.

The American Adventure; Saltergate, Chesterfield; Derbyshire Royal Infirmary: These three locations are now all residential housing developments or scheduled for development and very little evidence of their former uses survive other than the towers at the latter, which cannot currently be accessed by the public.

Notes

1. The High Peak

1. The former was opened to great aplomb by board chairman Sir Edward, yet Derwent's official opening four years later passed with far less fanfare, given the country was at war.
2. It would eventually be completed in 1945 before being opened by George VI on 24 September 1945.
3. Sutton had died prior to the reservoir's completion.

2. North East Derbyshire

1. Jewitt, Llewellynn, *The reliquary; A depository for precious relics-legendary, biographical and historical, Illustrative of the habits, customs and pursuits of our forefathers*, Vol. 2 (1862).
2. derbyshireheritage.co.uk/buildings/others/trinity-chapel.
3. derbyshireheritage.co.uk/buildings/others/trinity-chapel.
4. It would enjoy one final hurrah, however, on 18 May 1913, fifty-seven years after it closed its doors, with a service held in the ruins of the chapel.
5. It's widely acknowledged by numerous historians, such as academic and author Alison Weir among others, that Bess was, at the time, the second-richest woman in the country, after Elizabeth I.

3. Derbyshire Dales

1. www.railengineer.co.uk/hidden-haddon-its-rise-and-fall.

4. Amber Valley

1. As lord of the manor at Alderwasley Hall, these days an independent school, Hurt's plan was for the estate to pass to his eldest son and heir, also named Francis – as were all lords of the manor of Alderwasley Hall between 1763 and 1861.
2. Ham, Canon H., *The Diocesan Retreat House* (1927).

3. Later changed to Heanor Secondary School and becoming a grammar school in 1944.
4. www.ambervalley.gov.uk.

5. Derby and South Derbyshire

1. Rippon, Nicola, *The Plot to Kill Lloyd George: The Story of Alison Wheeldon and the Peartree Conspiracy* (2009).
2. *Derbyshire Life* magazine.
3. www.theatrestrust.org.uk/how-we-help/theatres-at-risk/183-derby-hippodrome.

6. Reclaimed

1. www.derwentvalleymills.org/discover/derwent-valley-mills-history/derwent-valley-mills-key-sites/key-sites-cromford-mill.
2. www.cromfordmills.org.uk/learning/mill-history.

Bibliography

Books

Adshead, David, *Hardwick Hall: A Great Old Castle of Romance* (New Haven: Yale University Press, 2016)

Appleton, Mike, *50 Gems of Derbyshire* (Stroud: Amberley Publishing, 2018)

Bailey, Stephen, *The Old Roads of Derbyshire, Walking Into History: The Portway and Beyond* (Market Harborough: Troubador Publishing, 2019)

Bradley, Richard, *Secret Matlock & Matlock Bath* (Stroud: Amberley Publishing, 2018)

Bull, John, *The Peak District: A Cultural History* (Oxford: Signal Books, 2012)

Burgess, Neil, *Derbyshire's Lost Railways* (Catrine: Stenlake Publishing, 2010)

Burkinshaw, Elaine, *Historic Walks in Derbyshire* (Milnthorpe: Cicerone Press, 2003)

Colvin, Howard, *Calke Abbey, Derbyshire: A Hidden House Revealed* (Michigan: Sheridan House, 1985)

Craven, Maxwell, *Derby Past and Present* (Cheltenham: The History Press, 2004)

Craven, Maxwell, *Derby Through Time* (Stroud: Amberley Publishing, 2014)

Craven, Maxwell, *The Lost Houses of Derbyshire* (Nottingham: Landmark Publishing, 2002)

Eardley, Denis, *Derby From Old Photographs* (Stroud: Amberley Publishing, 2017)

Farmer, Adrian, *Derwent Valley Mills Through Time* (Stroud: Amberley Publishing, 2015)

Fisk, Stephen, *Abandoned Villages* (Stroud: Amberley Publishing, 2018)

Ham, Canon H., *The Diocesan Retreat House* (1927)

Hancock, Gerald, *Goyt Valley Romance, Errwood Hall & the Grimshawes* (Gerald Hancock, 2001)

Haslam, Vic, *Silent Valley: A History of the Derbyshire Villages of Ashopton and Derwent, Now Submerged Beneath Ladybower* (Sheffield: Sheaf Publishing, 1983)

Hey, David, *A History of the Peak District Moors* (Barnsley: Pen & Sword, 2014)

Jewitt, Llewellynn, *The reliquary; A depository for precious relics-legendary, biographical and historical, Illustrative of the habits, customs and pursuits of our forefathers*, Vol. 2 (1862)

Kingscott, Geoffrey, *Lost Railways of Derbyshire* (Newbury: Countryside Books, 2007)

Long, David, *Lost Britain: An A–Z of Forgotten Landmarks and Lost Traditions* (London: Michael O'Mara, 2015)

Lovell, Mary S., *Bess of Hardwick* (Boston: Little, Brown Book Group, 2009)

Rippon, Nicola, *The Plot to Kill Lloyd George: The Story of Alison Wheeldon and the Peartree Conspiracy* (Barnsley: Wharncliffe Books, 2009)

Smith, Michael E., *Industrial Derbyshire* (Stoke-on-Trent: Breedon Books Publishing, 2012)

Stone, Richard, *Buildings in Derbyshire: A Guide* (Stroud: Amberley Publishing, 2011)

Sugden, Simon, *Derelict Britain: Beauty in Decay* (Stroud: Amberley Publishing, 2020)

Websites

aircrashsites.co.uk
ambervalley.gov.uk
bbc.com/travel/article/20190924-the-lost-villages-of-the-derwent-valley
brackenfield.org
cromfordmills.org.uk
derbyshireheritage.co.uk
derbyhippodrometrust.org
derbyshirehistoricbuildingstrust.org.uk
derbymuseums.org
derwentvalleymills.org
english-heritage.org.uk
goyt-valley.org.uk/errwood-hall
haddonhall.co.uk
nationaltrust.org.uk
peakdistrict.gov.uk
pdmhs.co.uk/magpie-mine-peak-district
railengineer.co.uk/hidden-haddon-its-rise-and-fall
rdht.org.uk/butterley-company
theatretrust.org.uk
visitpeakdistrict.com
wondersofthepeak.org.uk

Acknowledgements

I am indebted to the wonderful photographers and image right holders who have kindly allowed me to use their work and bring the places and stories in *Abandoned Derbyshire* to life, some of whom have gone above and beyond by taking on photographic missions specifically for use in this book. Thank you too to the many who generously offered photographs that unfortunately didn't make the final cut.

Specific thanks go to Becky Adlington, Ian Bartley, Richard Bradley, Paul Browne, Amelia Campbell, Tim Castledine, Maxwell Craven, Mark Day, Mike Edwards, Chris Eyre, Adrian Farmer, Richard Felix, Clare O'Flanagan, Debbie Jarrett, Tina Jenner, Matthew Jones, Steve Lilley, Ethan Lloyd, Kirsten Marsh, Helen Moat, Pygarian Nox, Mike Onslow, Stephanie Reaney, Ian Richardson, Robin Spencer, Cath Turkington, Gary Wallis, Julie Webster and Lost Places & Forgotten Spaces.

Every attempt has been made to seek permission for copyright material used in this book. However, if we have inadvertently used copyright material without permission/acknowledgement we apologise and will make the necessary correction at the first opportunity.

I would also like to thank the many local organisations who have offered their support. These include Brackenfield Village Association, Butterley Ironworks Trust, Derbyshire and Proud Facebook Group, Derbyshire Historic Buildings Trust, Derby Hippodrome Restoration Trust, Marketing Peak District & Derbyshire, and Natural Eckington.

Thanks also to Nick Grant at Amberley Publishing and, finally, my family – Rebecca, Aurora and baby Lottie – for suffering your own abandonment during the many evenings I spent writing this book!